DATE DUE

National Galleries of Scotland

PRINTED IN U.S.A.

National Gallery of Scotland
Scottish National Portrait Gallery
Scottish National Gallery of Modern Art

National Galleries of Scotland

SCALA BOOKS

© 1989 The Trustees of the
National Galleries of Scotland

First published in 1989 by
Scala Publications Ltd
26 Litchfield Street
London WC2H 9NJ

Distributed in the USA by
Harper & Row, Publishers
10 East 53rd Street
New York, NY 10022

ISBN 1 870248 30 9 (hardback)
ISBN 1 870248 35 X (paperback)

Designed by Alan Bartram
Edited by Paul Holberton
Filmset by August Filmsetting, England
Colour separations by Summerfield Press, Florence
Printed and bound in Italy
by Graphicom, Vicenza

FRONT COVER
Sir Henry Raeburn, *The Reverend Robert Walker
skating on Duddingston Loch* 1784

BACK COVER
Diego Velázquez, *Old woman cooking
eggs* 1618 (detail)

Contents

Introduction

The National Galleries of Scotland in Edinburgh constitute a trinity of buildings led by the National Gallery on the Mound, which serves as the flagship. The main holdings consist of Western European and American paintings dating from the Middle Ages to the present day, and a major collection of sculpture, watercolours, drawings, prints, and photographs. The paintings collection, though relatively small, boasts a great number of masterpieces. The other great strength is what must be the most nearly definitive representation anywhere of Scottish paintings. This volume illustrates a broad selection of the masterpieces of Western European Art, but only token examples of Scottish works as these will be the subject of a separate publication. It also reproduces some pictures on long-term loan, especially a selection from the celebrated Orleans Collection, most generously lent to us by the Duke of Sutherland since 1946.

The National Gallery on the Mound houses the Old Masters including Raphael, Titian, Rubens, Rembrandt, Poussin, Velázquez, right up to the Impressionists and some Post Impressionists. The chronological sequence continues at the National Gallery of Modern Art, which moved from the Royal Botanic Garden to its new premises in Belford Road in 1984. This collection, richer in American work, also contains a rapidly increasing group of 20th century photographs and certain experimental pieces which resist traditional definition. The modern collection is only just over 20 years old, and regrettably still lacks substantial masterpieces of comparable quality to those hanging at the Mound. Many of the pictures tend to be of small format, as they were bought for the old gallery which had no large rooms. The sculpture collection, however, is particularly well chosen and extensive.

The Scottish National Portrait Gallery brings together images of famous Scots from the Renaissance until the present day. In recent years it has widened its scope to become more a museum devoted to Scottish history, art and life, collecting in tandem, to a modest extent, historical scenes and subjects of topographical, iconographic and associative interest. The Portrait Gallery also houses and displays the Scottish Photography Archive and collection, and pursues a very active policy in commissioning portraits of a variety of celebrated living Scots.

The history of the National Galleries of Scotland is very complex. Its origins stretch back to the Treaty of Union of 1707 when the Board of Manufactures, a uniquely Scottish government department, was set up to relieve poverty, making use of Treasury funds to encourage the manufactures. To this end, in 1760, the Board established a Drawing Academy in Edinburgh, and by 1822 had built a fine Doric structure on the Mound, designed by the architect W H Playfair (1790-1857), to house the Academy and a number of other institutions including the Royal Society, the Society of Antiquaries and the Institution for the Encouragement of the Fine Arts. The last was founded in 1819, with a Royal Charter in 1827. The Royal Scottish Academy, founded in 1826, which was the premier society of Scottish artists, also made use of the Board of Manufactures' building for its annual exhibitions. Unfortunately the Board, the Institution and the Royal Scottish Academy all had collections to house, and there was not enough space available for them in the Board's existing building.

By the mid-nineteenth century there was a desire in Edinburgh to bring these collections together, both rehousing the Royal Scottish Academy and at the same time founding a Scottish National Gallery. The new building, which it was resolved to construct for the purpose, was erected on the Mound immediately to the south of the Board's building. The foundation stone was laid by H R H Prince Albert on 30 August 1850 and the new building was opened in 1859. Also designed by Playfair, it was built in the classical taste with an Ionic order and consisted of two large enfilades of octagonal top-lit rooms, the suite on the west intended for the new National Gallery and that on the east for the Royal Scottish Academy. The octagons, linked by round-headed arches, were provided with claret-painted walls, a green Dutch-weave carpet and geranium-pink pedestals to support the white marble sculpture. All this was executed to the design of Playfair's collaborator D R Hay (1798-1866), a celebrated colour theorist and expert on optics, who was described in his day as 'the first intellectual house-painter'. But as the century drew to its close, it became very evident that there were not enough rooms even in this building for both the National Gallery and the Royal Scottish Academy. And so it was agreed in 1906 that the Academy should move back to its former home, and in 1912, after architectural modifications, the whole of the southern building was re-opened for the exclusive use of the National Gallery – which thereby doubled its exhibition space.

By this time, the Gallery already possessed many pictures of real importance, including 26 bought on behalf of the Institution for the Encouragement of Fine Arts in 1830-31 in Genoa and Florence by the landscape painter Andrew Wilson, partly on the advice of Sir David Wilkie. This purchase, which formed the nucleus of the nation's art collection, was made only six years after John Julius Angerstein's collection was acquired as the basis of the National Gallery in London. Perhaps the finest canvas was

the splendid *Lomellini family* by Van Dyck, but there were also two other magnificent Van Dycks, *St Sebastian bound for martyrdom* and a full-length *Portrait of an Italian nobleman*. Other capital works included Paris Bordone's *Venetian woman at her toilet*, Jacopo Bassano's portrait of a gentleman, Guercino's *Madonna and Child with St John* and *St Peter Penitent*, and works by Paggi, Cambiaso, Scorza, Furini, Weenix and Van Delen. The Academy had also acquired in 1829-30, as a work of modern art, the vast *Judith and Holofernes* triptych by William Etty, then regarded as a triumph of the contemporary historical style. Later, but before the 1859 opening, the Institution and the Academy between them purchased other great pictures including Tiepolo's *Finding of Moses* (1845) and *Meeting of Anthony and Cleopatra* (the same year), Jacopo Bassano's *Adoration of the Magi*, then believed to be by Titian (1856), Zurbaran's *Immaculate Conception* and Gainsborough's glorious full-length portrait of *The Hon Mrs Graham* (1859). Over and above this were all the fine pictures, marble sculptures, vases and bronzes from the Erskine of Torrie bequest to the University of Edinburgh, which were placed on long loan to the Board of Manufactures in 1845, and of which some remain with the Gallery today.

The opening of the new National Gallery in 1859 acted as a catalyst for further gifts and bequests, the most notable being that of Lady Murray of Henderland in 1861 which comprised the collections of Allan Ramsay the painter and his son, General John Ramsay. This bequest included many oils and drawings by Ramsay himself (not least the ravishing portrait of his second wife), as well as paintings by Watteau, Lancret, Pater, Boucher and Greuze.

In spite of generous donations, the Scottish National Gallery in the late nineteenth century was at a grave disadvantage when trying to acquire works of art competitively, for it had no monies provided by H M Treasury. This was at a time when the London National Gallery and also the great civic galleries at Manchester, Liverpool and Glasgow, were provided with purchase grants. The Rt Hon William McEwan MP (1827-1913), Chairman of McEwan's Brewery, helped significantly in the 1880s and '90s, buying for the National Gallery a fine pair of portraits by Franz Hals and Rembrandt's matchless *Woman in bed*, dating from the 1640s. McEwan's younger contemporary W A Coats (1853-1926), a partner of J & P Coats, the thread-manufacturing firm of Paisley, collected paintings avidly, the majority French and nineteenth-century, among them 13 Corots, 16 Monticellis, 3 Boudins and 7 Géricaults. In 1901 he bought from the dealers Forbes and Paterson, Scotsmen settled in London, the great early signed Vermeer of *Christ in the house of Martha and*

Mary, which his two sons presented in Coats's memory in 1927.

After a great deal of pressure, the Treasury finally agreed, from 1903/4, to grant the Scottish National Gallery £1,000 a year for the purchase of works of art. The sum, although a blessing, was still far from adequate. Then in 1919 Mr James Cowan Smith, the son of a shipowner from Banffshire, who had settled in Yorkshire, bequeathed £55,000 to the Gallery, the interest on which was to be used for the purchase of works of art. The terms of this bequest were curious: the Gallery had to accept and hang a portrait of Mr Cowan Smith's favourite Dandie Dinmont terrier *Callum*, painted by John Emms. The Trustees also had to provide for the care of his dog Fury, who survived him. Fury was put in the care of Mr Wing, a coachman. With the help of the Cowan Smith fund, several excellent pictures were purchased, including Turner's *Somer Hill* in 1922, J S Sargent's *Lady Agnew of Lochnaw* in 1925 and Constable's *Vale of Dedham* in 1944.

There were many other generous gifts and bequests but few so distinguished as that of Mrs Nisbet Hamilton Ogilvy of Biel, who died in 1920. This consisted of four generations of pictures bought by her husband's family and included two portraits of *Lady Robert Manners*, one as a girl by Ramsay and one as an old lady by Lawrence, a full-length portrait of her daughter *Mary Nisbet* by Gainsborough and a head and shoulders of her grand-daughter *Mary, Lady Elgin* painted by Gérard.

The Gallery also benefited from a still older family collection with the bequest of the eleventh Marquess of Lothian in 1941. This included 18 pictures of which 13 dated from the sixteenth century or earlier. Much of the collection had been assembled by the eighth Marquess of Lothian, the author of a book entitled *Fragment of a Parallel between the History, Literature and Art of Italy in the Middle Ages* which was privately published in 1863: amongst pictures of special note were the *cassone* front by Apollonio di Giovanni of the *Triumph of Love and Chastity*, Sellaio's *Man of Sorrows* and Cranach's *Venus and Cupid*. He also owned Filippino Lippi's *Coronation of the Virgin*, now in the National Gallery, Washington, and Piero di Cosimo's *Vulcan and Aeolus*, now in the National Gallery, Canada.

Visitors to the National Gallery particularly admire and remember the very splendid collection of French Impressionist and Post-Impressionist pictures. Twenty-two of these were given or bequeathed by Sir Alexander Maitland QC (1877-1965), the son of a Dundee merchant and sometime Liberal parliamentary candidate and Sheriff of Caithness, Orkney and Shetland. He and his wife Rosalind, who was keenly interested in music, lived in

1 National Gallery of Scotland, with the Castle behind

2 Scottish National Gallery of Modern Art

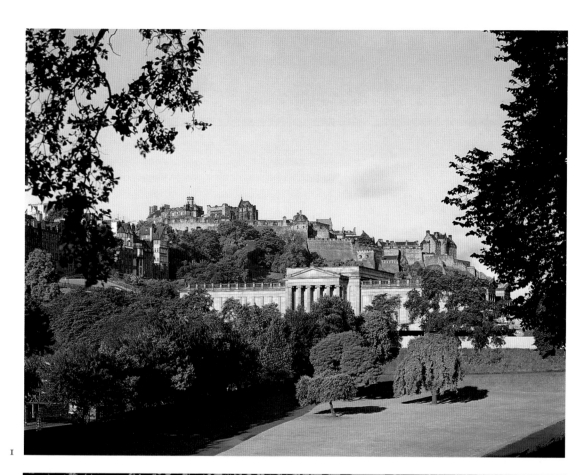

1

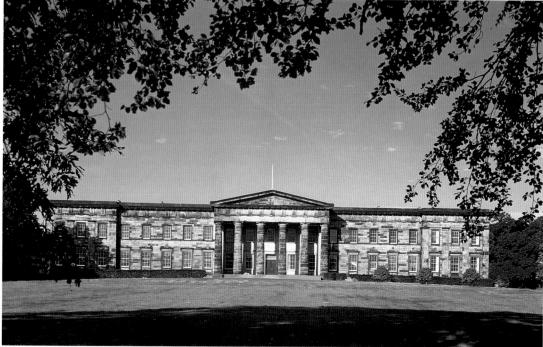

2

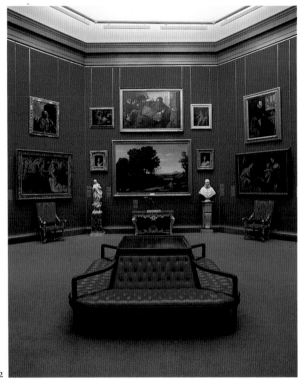

1

2

Heriot Row, Edinburgh, where their house, filled with great pictures and sculpture, also became celebrated as a musical salon. Lady Maitland had studied music in the Berlin Hochschule and with her mother Mrs Craig-Sellar had visited Rodin's studio in Paris, where they bought the marble carving of the *Young mother* which is now in the Gallery. The collection contains two superlative Gauguins, *Martinique landscape*, bought in 1932, and *Three Tahitians*, bought in 1935. Then there is a Seurat, a Van Gogh, Monet's *Haystacks* and Cézanne's *Mt Ste-Victoire*. The display of the Maitland collection is now divided between the Mound and the National Gallery of Modern Art, which houses fine pictures by Bonnard, Rouault, an early Picasso and Matisse's memorable *Leçon de peinture*.

Another collection of considerable importance that is now divided between the two Galleries is the so-called Richmond-Traill gift. This consists of pictures bought by Sir John Richmond (1869-1963), senior deputy chairman of the Glasgow engineering firm of G & J Weir, Chairman of the Glasgow School of Art and President of the Royal Glasgow Institute. A Trustee of the National Galleries of Scotland (1942-47), he was a quiet, unassuming character who was particularly interested in literature, counting among his friends Arnold Bennett and Hilaire Belloc. He bought almost exclusively from Alex Reid, the leading art dealer in Glasgow, whose superb portrait by Van Gogh now graces the walls of the Glasgow Museum and Art Gallery. His collection was left to his niece Isabel Traill who made her own additions and gave most of it to the Scottish National Galleries in 1980. Its treasures include Monet's *Church at Vétheuil* (1878), Camille Pissarro's *Kitchen-garden at L'Hermitage, Pontoise* (1874), Sisley's *The Seine at Suresnes* (1880) four Vuillards, two Monticellis and a Boudin.

The National Gallery has been fortunate to have received many splendid loans, of very special importance being the group of paintings that have been lent by the Duke of Sutherland since 1946, and which once formed part of the Orléans collection. These pictures are undoubtedly the most distinguished group in private hands in the United Kingdom. The Royal Family has since 1912 most graciously lent the *Trinity* panels by Hugo van der Goes, most precious survivors of fifteenth-century art in Scotland. Painted c1478-79 probably for Sir Edward Bonkil, first Provost of the Collegiate Church of Holy Trinity, Edinburgh, they include a portrait of the patron kneeling in prayer before the *Holy Trinity of the Broken Body*.

The National Gallery of Modern Art at Belford Road houses the continuation of the collection. The caesura is not religiously adhered to. Rather than split artists' *œuvres* there is a tendency for those artists who appear to be

perhaps a little more avant-garde, or international, to go to Belford Road while the more traditional painters remain at the Mound. The building in which these are housed is a handsome Neoclassical pile (1825-28) designed by William Burn. It was erected originally as an orphan school and only converted for its present use in 1981-84. Previously the collections had been housed in Inverleith House, in the Royal Botanic Garden. That elegant, small eighteenth-century house was first opened to the public as a gallery by Sir Kenneth (later Lord) Clark, sometime Trustee of the Scottish National Galleries, on 10 August 1960. By 1966 the inadequacy of the Gallery space was recognised by the Trustees, hence the move ultimately to the Belford Road site.

The Scottish National Gallery of Modern Art is not yet as generously endowed with masterpieces as the Mound. Nevertheless, the holding of twentieth-century Scottish art is surely unrivalled. The major obstacles to the acquisition of masterpieces of contemporary art of international significance have been lack of money and the absence of Scots who have collected in the international field, and given their treasures to the National Gallery. For the early twentieth century, the most significant single gift was from the Maitland collection previously mentioned, followed by the Richmond-Traill gift also mentioned. In 1945 Sir David Young Cameron (1865-1945) bequeathed a group of works by his contemporaries such as Epstein, Gill, Augustus John and Monnington. These were transferred from the Mound in 1960, while Cameron's excellent collection of Rembrandt etchings, which he had also presented to the National Gallery, remained there. Then R R Scott Hay in 1967 and Dr R A Lillie in 1977 presented large groups of Scottish works. Amongst the many other generous benefactors should be mentioned especially Sir James and Lady Caw, Stanley Cursiter (artist and former Director of the National Galleries), Alan Stark, H S Ede, Gabrielle Keiller and Alan Roger. In 1987 Mrs P M Black gave some 250 sketches by her sister Joan Eardley. The major thrust since 1960 has, however, been to buy twentieth-century European art and its success is clearly demonstrated by the variety and quality of the works acquired.

The Scottish National Portrait Gallery, a Gothic Revival red sandstone building on Queen Street, was founded in 1882 and formally opened to the public by the then Secretary of State, the Marquess of Lothian, on 15 July 1889. The Portrait Gallery was designed by Sir Robert Rowand Anderson and paid for by the proprietor of the Scotsman newspaper, John Ritchie Findlay. Intended as 'the highest incentive to true patriotism', from the outset it shared its premises with the National Museum of

Antiquities. They were supposed to be there only on a temporary basis; a hundred years later they still occupy the building. Above all the Portrait Gallery seeks to collect and display images of distinguished, celebrated or even infamous Scots, whether in paintings, sculptures, prints, drawings, commemorative medallions or photographs. The faithful contemporary image is of more significance than the quality of the picture itself. The majority of works are by Scottish artists, including fine examples by David Allan, James Archer, Andrew Geddes, Sir Francis Grant, Gavin Hamilton, Sir Daniel MacNee, David Martin, Sir William Orchardson, Raeburn, Ramsay and Wilkie. There are also great works by English artists, among them Beechey, Dobson, Flaxman, Gainsborough, Kaufmann, Lawrence, Northcote, Opie, Romney and Wilson, and fine examples by foreign artists working in Britain such as Danloux, Mytens (the great full-length of the First Duke of Hamilton of 1629), Lely, Kneller and Wissing. Otherwise the Gallery boasts a fascinating group by Continental painters, demonstrating the degree to which Scots travelled the world, including David d'Angers, Batoni, Carmontelle, Gérard, Ghezzi, Greuze, Kokoschka, Franz von Lenbach, Corneille de Lyon, Masucci and Tischbein.

Between them, the three National Galleries of Scotland attempt to cover most aspects of the fine arts between c 1300 and the present day. That, in a relatively small country with a small population and slim resources, they have been so successful is a tribute to generations of benefactors – not forgetting generous lenders –, trustees and staff who have striven hard to create this remarkable collection.

Sir David Young Cameron, the celebrated Scottish painter and etcher who had been a Trustee for the last 25 years of his life, once observed 'How often in going through the great Florentine galleries our own came to mind and made me realise how many fine things there are in it. Indeed, in proportion to its size, we have more things of varied excellence than most galleries, and we have but little padding.'

TIMOTHY CLIFFORD
Director, National Galleries of Scotland

Italian School

This is, outside the National Gallery in London and the British Royal Collection, probably the finest collection of Italian paintings in the United Kingdom. The holding of fourteenth- and fifteenth-century pictures is limited, but includes some memorable panels, such as Lorenzo Monaco's *Madonna*, the tiny Butinone of *Christ disputing with the Doctors*, and the *Last Supper* by a close associate of Andrea del Castagno. The Gallery boasts a good triptych by Bernardo Daddi, two predella panels by the Master of the St Lucchese altar and a delightful Vitale da Bologna of the *Adoration of the Kings*. The biggest image is Cosimo Rosselli's *St Catherine of Siena as the Spiritual Mother of the Second and Third Order of St Dominic*, that was perhaps painted for the church of San Domenico al Maglio, attached to the convent of St Catherine of Siena in Florence. Most appealing are the two Filippino Lippi, especially the *Nativity*, where the Virgin kneels in adoration before the Christ Child, flanked by angels, with St Joseph seated to the left looking on. Very different is the Ferrarese School *Madonna and Child with two angels*, which contains a curious visual conceit of *trompe l'oeil* torn material around the edges of the frame, a feature which is open to a variety of interpretations. The so-called *Ruskin Madonna* by, or attributed to, Andrea del Verrocchio, although severely damaged, is quintessentially fifteenth-century Florentine, full of tranquil grace and purity. This *Madonna* must number amongst the best loved pictures in the Gallery. Perugino's fragment of *Four nude figures* is very close to his documented work of *c*1505, the *Combat between Love and Chastity* now in the Louvre.

The greatest strength of the collection consists in its three Raphaels, five Titians and one Tintoretto on loan from the Duke of Sutherland since 1946. The most magnificent of the Raphaels is the *Holy Family with the palm-tree*, a Florentine *tondo* of *c*1506-07. Then there is the celebrated *Virgin and Child*, called the *Bridgewater Madonna*, painted rather later, and finally the *Madonna del Passeggio* which seems to have been designed by Raphael but executed by his close collaborator G F Penni. The earliest Titian must be the *Holy Family with St John the Baptist* which, although badly damaged, seems to date from about the same period as Titian's Paduan frescoes, that is, *c*1511. The next is the sublime *Three Ages of Man*, so like the *Sacred and Profane Love* in the Borghese Gallery, Rome, and painted around the same time *c*1514. The *Venus Anadyomene*, considerably later, is thought to date from after Titian's *Bacchus and*

Ariadne at the London National Gallery, *c*1523-25. Titian's *Diana and Actaeon* and *Diana and Callisto* are both known to have been painted for King Philip II and completed for shipping to Spain in October 1559. Other pictures in the series are *Danaë, Venus and Adonis* (both in the Prado), *Perseus and Andromeda* (Wallace Collection), *Rape of Europe* (Gardner Museum, Boston) and *Death of Actaeon* (National Gallery, London). The Gallery boasts a Lotto *Virgin and Child with Sts Peter, Jerome, Clare(?) and Francis* and Tintoretto's *Deposition of Christ* (formerly in the Bassi Chapel, San Francesco della Vigna, Venice) which were both bought from the Duke of Sutherland in 1984.

The collection is rounded off by three Paolo Veronese paintings (including the *Mars and Venus*), a Paris Bordon, one of the finest Jacopo Bassano, representing the *Adoration of the Magi*, and a good Moroni portrait of a scholar. Outside Venice the collection is less strong, although there is a splendid Del Sarto portrait, Bacchiacca's *Moses striking the Rock* and Poppi's *Golden Age*. Two curiosities are the pictures by Cambiaso and Paggi, bought with a large consignment of Old Masters in Genoa by the Scottish landscape painter Andrew Wilson and sold to the Royal Institution in Edinburgh in 1830.

The Bolognese School in the seventeenth century is richly represented, with the great Domenichino *Adoration of the Shepherds* which was bought as recently as 1971 from Dulwich College Picture Gallery, Dionisio Calvaert's little oil-on-copper *Holy Family*, the so-called *Moses and Pharoah's Crown* by his pupil Guido Reni and the majestic *Trinity* by Reni's pupil Cantarini. There are two good Guercino, *St Peter Penitent* and the *Madonna and Child with St John*. Massive is the *Raising of the Cross* probably painted by the Milanese artist Giulio Cesare Procaccini *c*1618-20. Although a century earlier, it makes an acceptable pendant to G B Pittoni's *St Jerome with St Peter of Alcantara and an unidentified Franciscan Saint* painted in the mid-1720s for the church of Santa Maria dei Miracoli, Venice. The greatest eighteenth-century picture is undoubtedly the majestic Tiepolo of the *Finding of Moses* that once used to hang at Lord Bute's house outside London, Luton Hoo. There is also a delightful, very resolved oil-sketch by Tiepolo for the *Meeting of Anthony and Cleopatra* for the Palazzo Labia, Venice. Another Venetian adequately represented is Francisco Guardi, with three Venetian *vedute*, while the Galleries have two good Batoni portraits.

Bernardo Daddi
active in Florence *c*1327 – 1348
The Crucifixion
Triptych, centre panel 53.3 × 28 cm,
wings 57.7 × 15.3 cm
Purchased 1938, NGS 1904

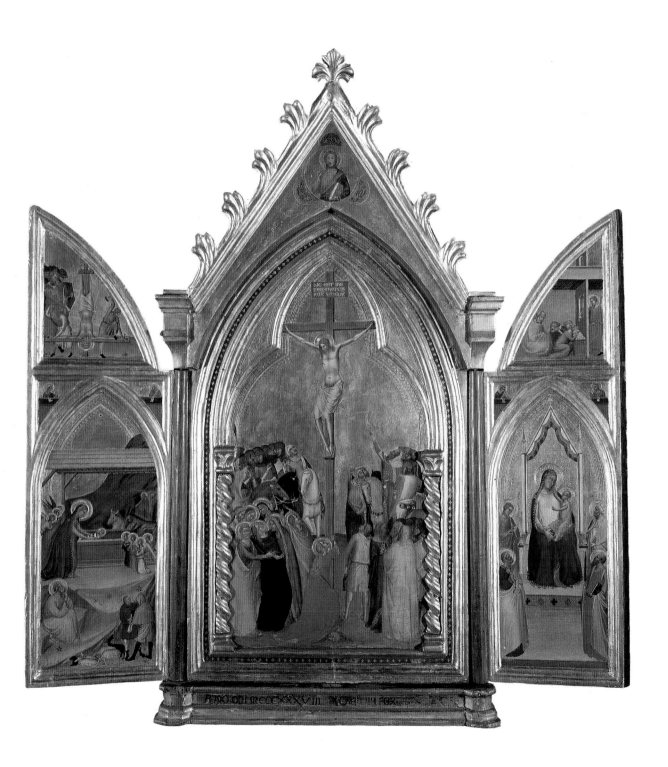

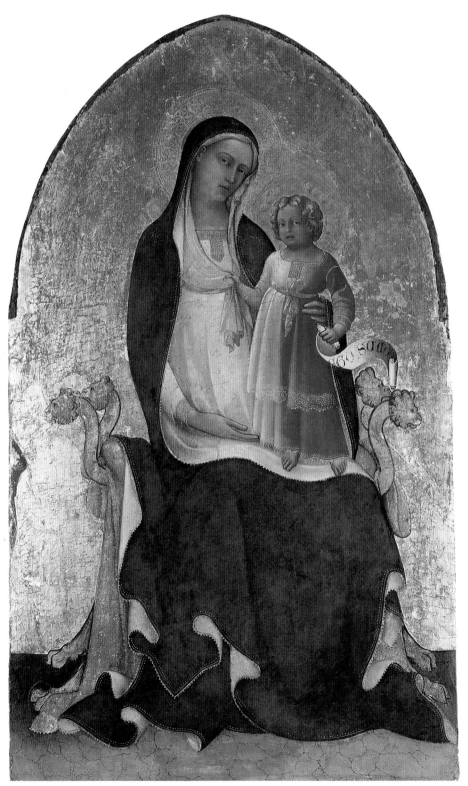

1

Lorenzo Monaco
active in Florence 1372 – 1422/4
Madonna and Child
Panel, 101.6 × 61.7 cm
Purchased 1965, NGS 2271

2

Andrea del Verrocchio
Florence *c*1435 – 1488 Venice
Madonna and Child
Canvas transferred from panel,
106.7 × 76.3 cm
Purchased with the aid of the NACF
and the Pilgrim Trust 1975, NGS 2338

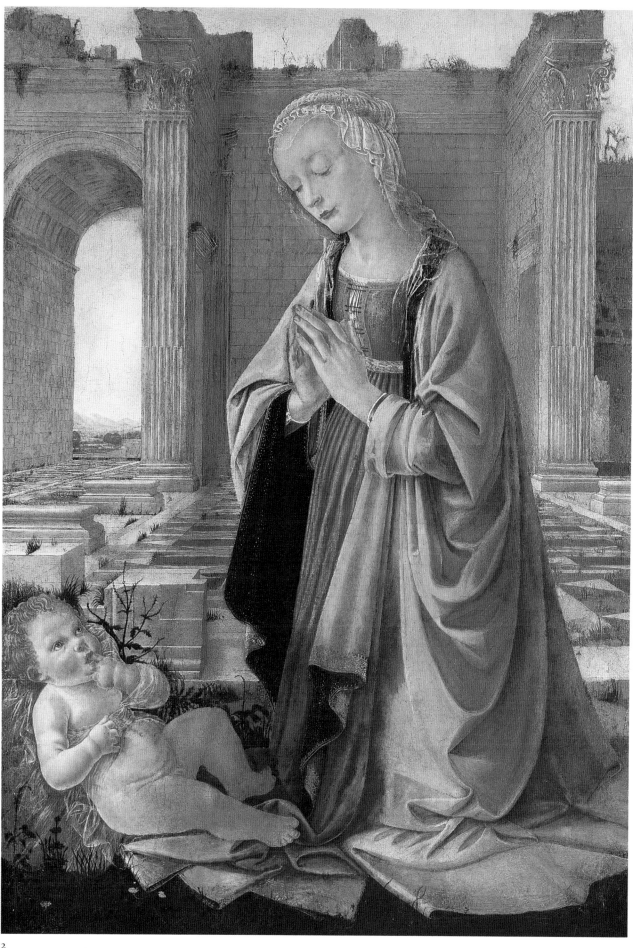

2

1
Pietro Vannucci il Perugino
Città della Pieve *c*1445/6 – 1523
Fontignano
A fragment: *Four male nude figures*
Linen, 73.5 × 55.5 cm
Presented by the NACF 1934, NGS 1805

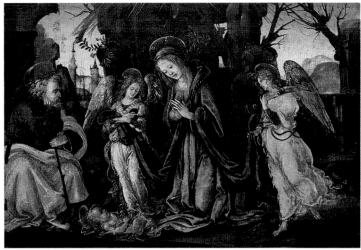

2

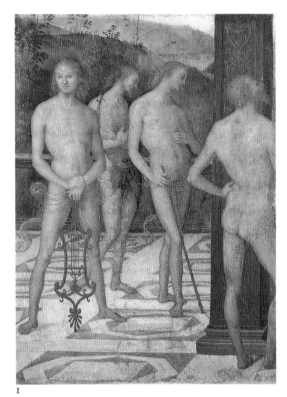

1

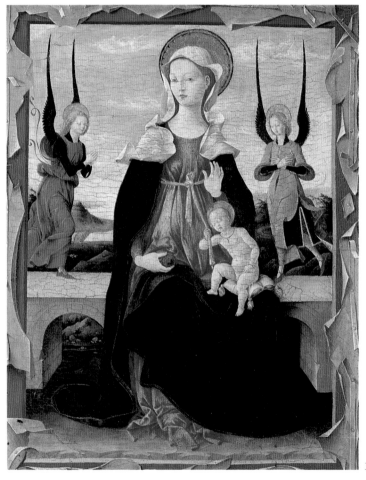

3

2
Filippino Lippi
Prato(?) 1457 – 1504 Florence
The Nativity with two angels
Panel, 25 × 37 cm
Purchased 1931, NGS 1758

3
School of Ferrara
15th century
Madonna and Child with two angels
Panel, 58.4 × 44.1 cm
Purchased 1921, NGS 1535

4
Bernardino Butinone
born Troviglio before 1436, died after
1507
Christ among the Doctors
Panel, 25.1 × 22.3 cm
Purchased 1930, NGS 1746

5
Raphael (Raffaello Sanzio)
Urbino 1483 – 1520 Rome
'La Madonna del Passeggio' c1516
Panel, 90 × 63.3 cm
Duke of Sutherland loan 1946

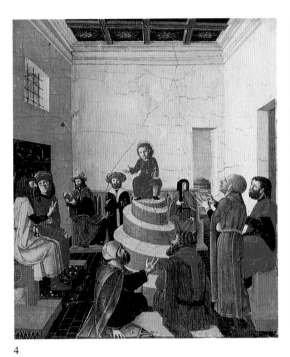

4

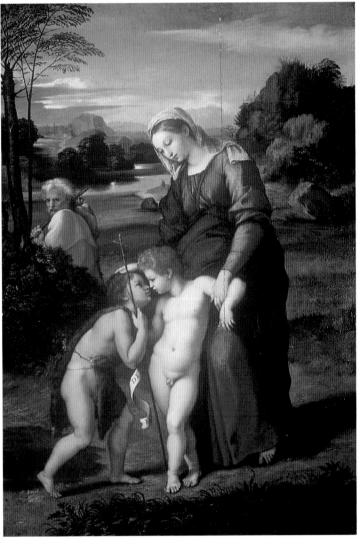

5

Raphael (Raffaello Sanzio)
Urbino 1483– 1520 Rome
Holy Family with a palm tree c1506-07
Canvas transferred from panel,
101.5 cm diameter
Duke of Sutherland loan 1946

The painting dates from the end of
Raphael's period in Florence c1506-

07, before he was summoned to Rome
by Pope Julius II late in 1508 or early
in 1509 to start work on the frescoes
in the Stanza della Segnatura in the
Vatican. A preparatory study in metal-
point of an early pose for the Virgin
and Child is in the Louvre, Paris. It is
possible that this was one of the two

pictures mentioned by Vasari as
painted for Taddeo Taddei in Florence.
It has also been suggested that it was
the painting described in the 1623
inventory of the collection of the Duke
of Urbino. The painting was almost
certainly in France by 1656, when it
was engraved by Gilles Rousselet.

Raphael (Raffaello Sanzio)
Urbino 1483 – 1520 Rome
The Bridgewater *Madonna*
Canvas transferred from panel,
81 × 56 cm
Duke of Sutherland loan 1946

1

Francesco Ubertini Verdi il Bacchiacca
Florence 1494/5 – 1557 Florence
Moses striking the Rock
Panel, 100 × 80 cm
Purchased 1967, NGS 2291

2

Titian (Tiziano Vecellio)
Pieve di Cadore *c*1488/9 – 1576
Venice
Venus Anadyomene c1525
Canvas, 76 × 57.3 cm
Duke of Sutherland loan 1946

3

Lorenzo Lotto
Venice *c*1480 – 1556/7 Loreto
Virgin and Child with saints
Canvas transferred from panel,
82.5 × 105 cm
Purchased with the aid of the NHMF
1984, NGS 2418

4

Titian (Tiziano Vecellio)
Pieve di Cadore *c*1480/90 – 1576
Venice
The Three Ages of Man c1510-15
Canvas, 90 × 150.7 cm
Duke of Sutherland loan 1946

More advanced in style than Titian's
documented frescoes in the Scuola del
Santo, Padua, of 1511, this picture
seems to date a little later, from the
same period as another of the artist's
allegorical paintings, '*Sacred and Pro-
fane Love*', in the Borghese Gallery,
Rome. The Three Ages of Man
(infancy, maturity and old age) are
symbolized by the sleeping babies, the
young couple and the old man con-
templating the two skulls. Whilst the
skulls suggest impending death, the
winged Cupid and the girl's crown of
myrtle, 'the plant of Venus', show that
love is also present. The recorders the
lovers hold perhaps signify the har-
mony of souls. The picture was listed
in the collection of Queen Christina of
Sweden c1662 and was later owned
by Philippe, Duc d'Orléans.

1

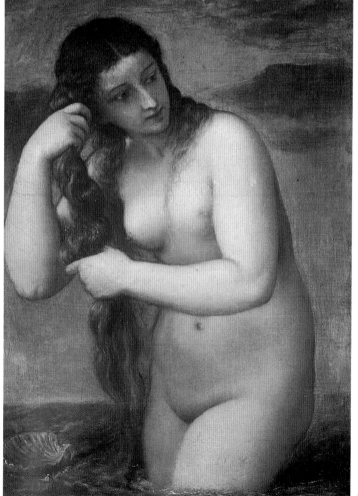

2

3

4

Titian (Tiziano Vecellio)
Pieve di Cadore *c*1488/9 – 1576
Venice
Diana and Actaeon 1556-59
Canvas, 184.5 × 202.2 cm
Duke of Sutherland loan 1946

This painting and its pendant, *Diana and Callisto*, were designed to form a set of *poesie* (poetical pictures), inspired by Ovid's *Metamorphoses* and painted for Philip II of Spain between *c*1550 and 1562. These two paintings were certainly finished by October 1559 when Titian sent them from Venice to

Genoa. The scene shows the hunter Actaeon discovering Diana and her nymphs at their grotto at Gargaphia. Actaeon's instrusion into their privacy was repaid by his transformation into a stag, caught and killed by his own hounds (Ovid, *Metamorphoses* iii, 138–253).

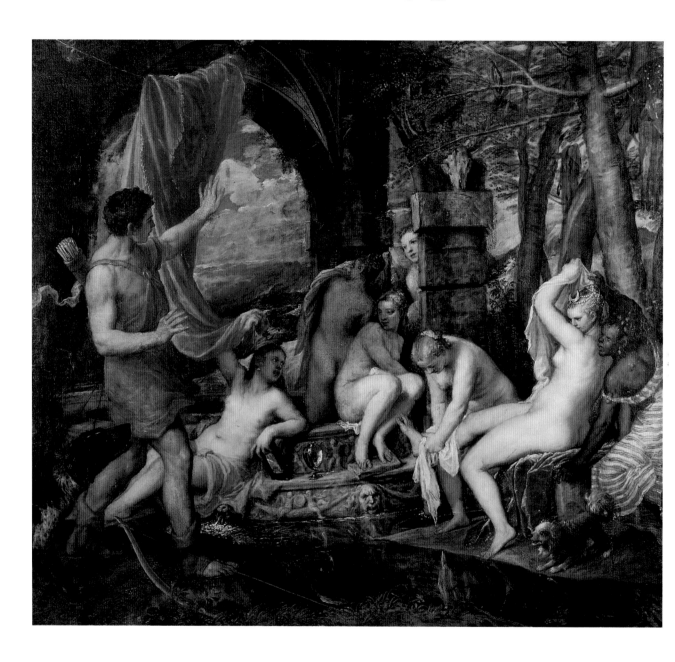

Titian (Tiziano Vecellio)
Pieve di Cadore *c*1488/9 – 1576
Venice
Diana and Callisto 1556-59
Canvas 187 × 204.5 cm
Duke of Sutherland loan 1946

A pendant to *Diana and Actaeon*, this painting also shows an episode from Ovid's *Metamorphoses* (ii, 457–65). Callisto, one of Diana's companions, was seduced by Jupiter (disguised as Diana herself), and this canvas shows how the disgrace of Callisto's pregnancy is revealed as the nymphs force her to undress to bathe. Banished by Diana, Callisto was then changed into a bear by Juno but was immortalized by Jupiter as the constellation of Ursa Major. Another version of this picture is in Vienna (Kunsthistorisches Museum).

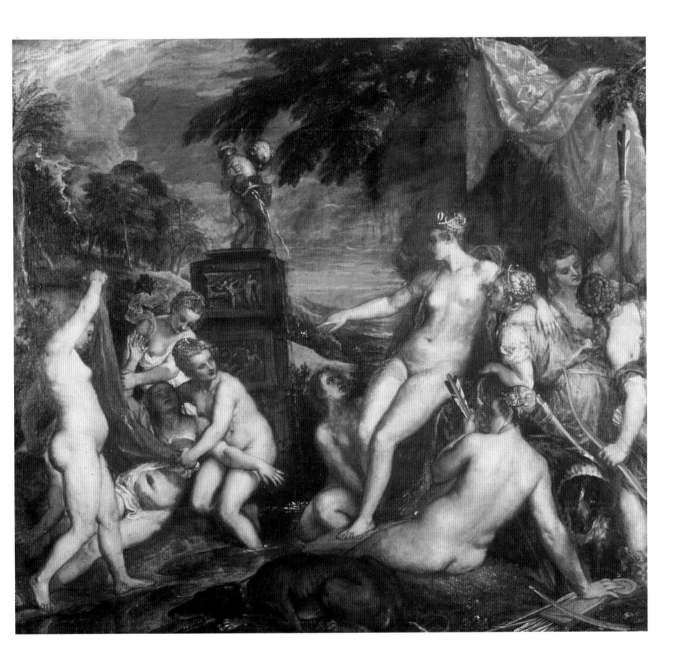

1
Giulio Romano
Rome *c*1499 – 1546(?)
Virgin and Child with the infant Baptist
*c*1518-23
Panel, 82.5 × 63.2 cm
Purchased with a National Heritage
Purchase Grant (Scotland) 1980,
NGS 2398

2
Andrea del Sarto
Florence 1486 – 1530 Florence
Becuccio Bicchieraio
Panel, 86 × 67 cm
Purchased 1967, NGS 2297

I

2

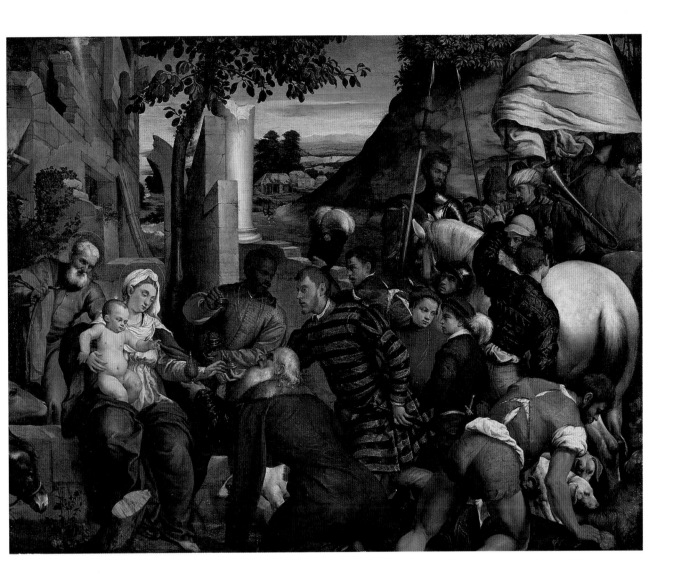

**Jacopo da Ponte, called Jacopo Bassano
Dal Ponte** *c*1510 – 1592 **Bassano**
*The Adoration of the Kings c*1540
Canvas, 183 × 235 cm
Transferred from the Royal Scottish
Academy 1910, NGS 100

Jacopo da Ponte was the leading
member of the family of painters who
took their name, Bassano, from the
town on the Brenta to the north-west
of Venice where they worked. This
painting is dated on the basis of simi-
larity to Bassano's work of the late

1530s and early 1540s, such as his
*Madonna with Sts Zeno and John the
Baptist* (Borso della Grappa, 1538).
The design for the *Adoration* is a devel-
opment from a large painting of *c*1539
at Burghley House. These works show
Bassano's early debt to Bonifazio Ver-
onese, in whose studio the artist
trained 1530-35. The ruined stable,
however, was inspired by Albrecht
Dürer's woodcut, *Sojourn of the Holy
Family*.

Jacopo Robusti, called Jacopo
Tintoretto
Venice 1518/9 – 1594 Venice
The Deposition of Christ 1550s
Canvas, 164 × 127.5 cm
Purchased with the aid of the NHMF
1984, NGS 2419

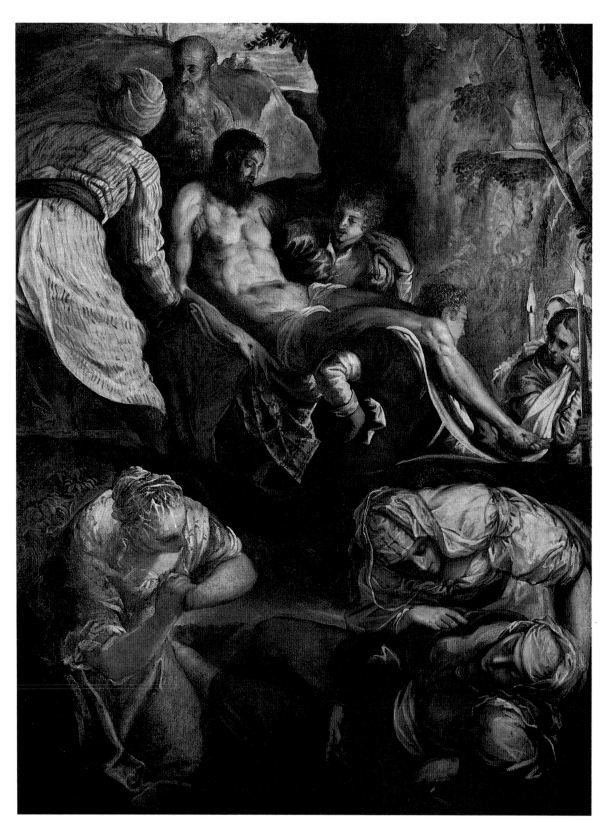

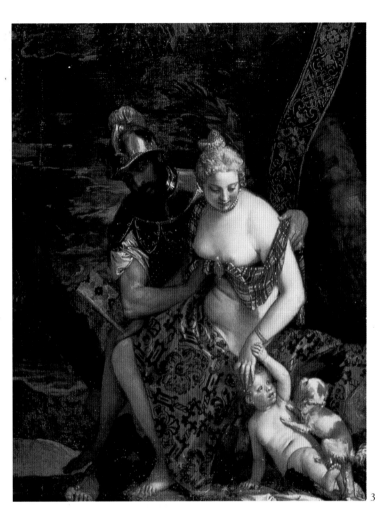

1
Giovanni Battista Moroni
born Albino, active by 1547 – 1578
Bergamo
Giovanni Bressani (1490 – 1560)
Canvas, 116.2 × 88.8 cm
Purchased 1977, NGS 2347

2
Francesco Morandini il Poppi
Poppi 1544 – 1597 Florence(?)
The Golden Age
Panel, 43 × 32.6 cm
Purchased 1964, NGS 2268

3
Paolo Caliari, called Paolo Veronese
Verona 1528 – 1588 Venice
Mars and Venus
Canvas, 165.2 × 126.4 cm
Transferred from the Royal Institution
1859, NGS 339

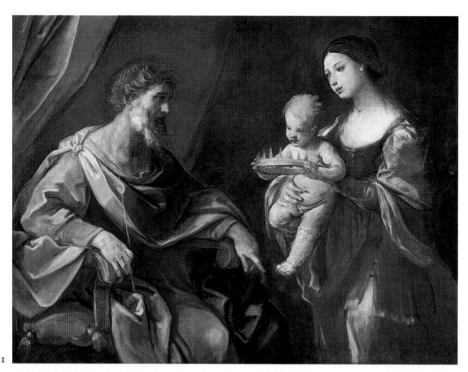

1

Guido Reni
Bologna 1575 – 1642 Bologna
Moses with Pharoah's Crown(?)
Canvas, 132 × 172.7 cm
Purchased 1979, NGS 2375

2

Giovanni Francesco Barbieri il Guercino
Cento 1591 – 1666 Bologna
Madonna and Child with the infant Baptist c1615-16
Canvas, 86.3 × 110 cm
Transferred from the Royal Institution 1858, NGS 40

3

Domenico Zampieri il Domenichino
Bologna 1581 – 1641 Naples
The Adoration of the Shepherds c1607-10
Canvas, 143 × 115 cm
Purchased 1971, NGS 2213

2

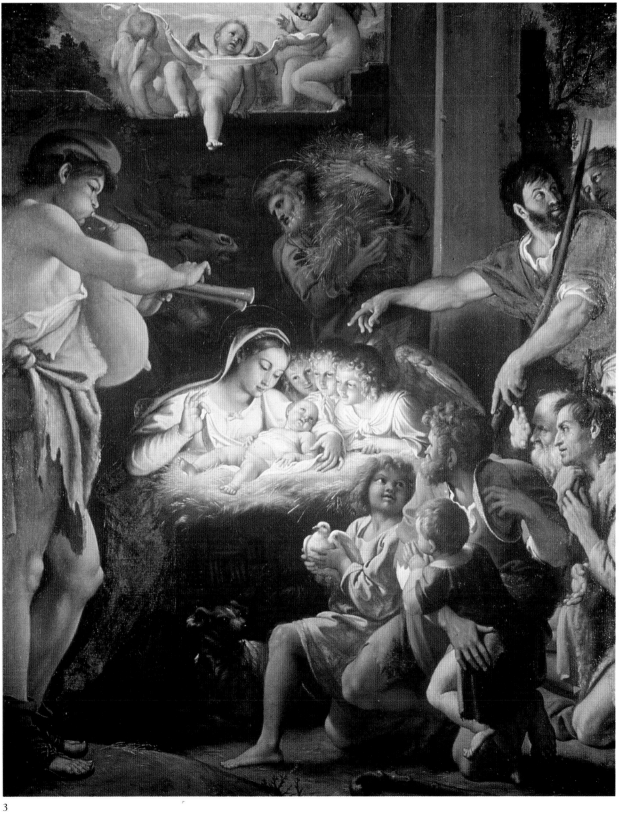

3

1

Gianlorenzo Bernini
Naples 1598 – 1680 Rome
Monsignor Carlo Antonio dal Pozzo
*c*1620
Marble, 82.5 cm
Purchased 1987, NGS 2436

2

Pier Leone Ghezzi
Rome 1674 – 1755 Rome
The Baptism of Prince Charles Edward
Stewart (1720-88)
Canvas, 243 × 350 cm
Purchased 1982, SNPG 2511

3

Agostino Masucci
active in Rome 1691 – 1758
The Marriage of Prince James Francis
Edward Stewart (1688-1766) *to Prin-*
cess Maria Clementina Sobieska (1702-
1735) *on 1st September 1719 c*1735
Canvas, 243.5 × 342 cm
Purchased 1977, SNPG 2415

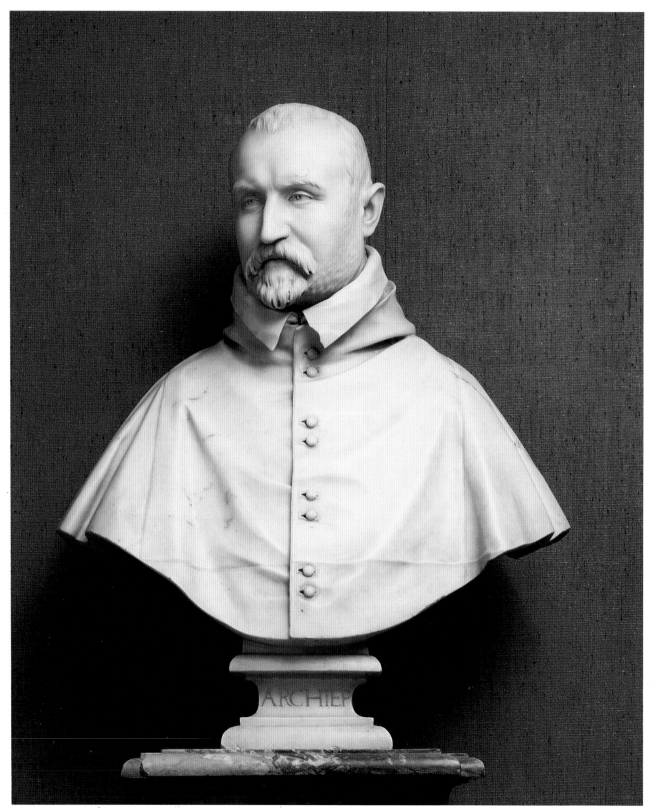

1

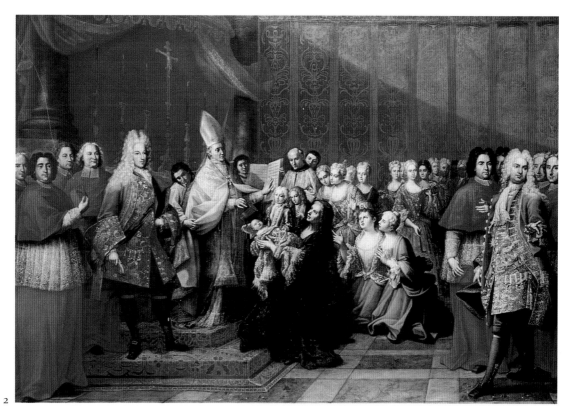

2

3

The Marriage of Prince James Francis
Edward Stewart, the Old Pretender, to
the Polish princess and heiress
Clementina Sobieska in 1719 was a
political event of some importance. It
strengthened the Jacobite's political

alliances across Europe and brought
much needed funds to their coffers.
Agostino Masucci was one of the lead-
ing Roman painters of the day and his
large canvas, and its companion the
Baptism of Bonnie Prince Charlie, the

son of this marriage, may have been
painted for the Palazzo Muti, the
Roman palace that the Pope, Clemen-
tina's godfather, gave the royal couple
as a wedding present.

1

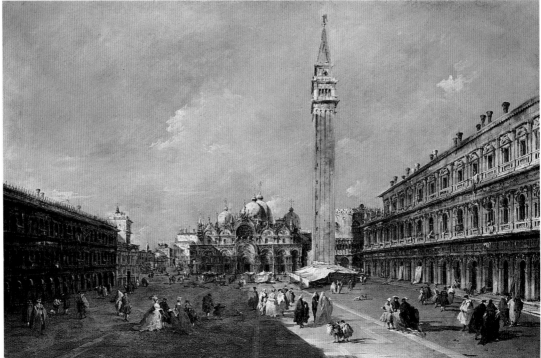

2

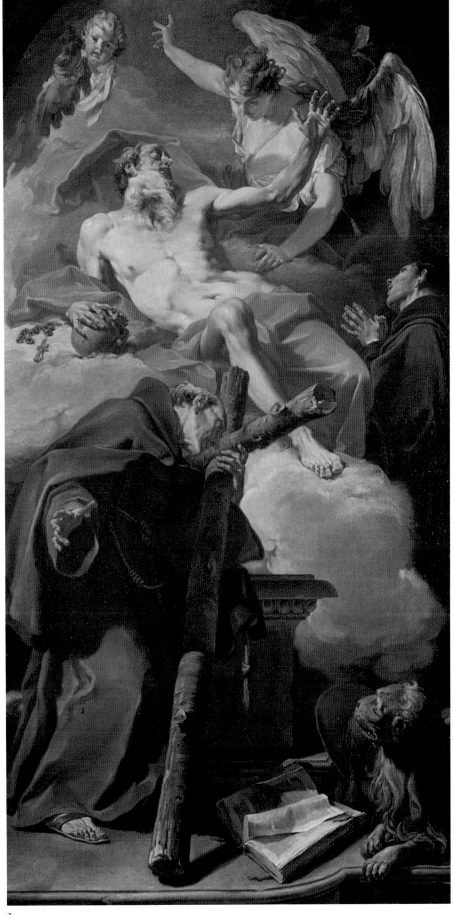

1
Giovanni Battista Tiepolo
Venice 1696 – 1770 Madrid
The Finding of Moses c1738-40
Canvas, 202 × 342 cm
Transferred from the Royal Institution
1858, NGS 92

2
Francesco Guardi
Venice 1712 – 1793 Venice
View of St Mark's, Venice
Canvas, 55.2 × 85.4 cm
Accepted in lieu of tax 1978,
NGS 2370

3
Giovanni Battista Pittoni
Venice 1687 – 1767 Venice
St Jerome with St Peter of Alcantara
c1725-27
Canvas, 275 × 143 cm
Purchased 1960, NGS 2238

3

1
Attributed to Pietro Fabris
active in Naples 1768 – 1778
Kenneth MacKenzie, Lord Fortrose
(1744-81) at home in Naples
Canvas, 35.5 × 47.6 cm
Purchased 1984, SNPG 2611

2
Antonio David
born Venice 1698
Prince Charles Edward Stewart
(1720-88) 1732
Canvas, 73.4 × 60.3 cm
Purchased 1918, SNPG 887

3
Pompeo Batoni
Lucca 1708 – 1787 Rome
James Bruce (1730-94) 1762
Canvas, 72.4 × 62.2 cm
Lady Ruthven bequest 1885, SNPG 141

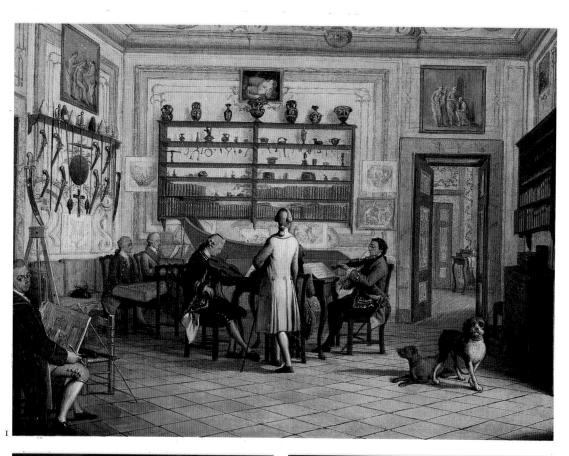

1

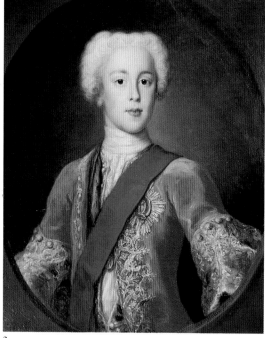

2

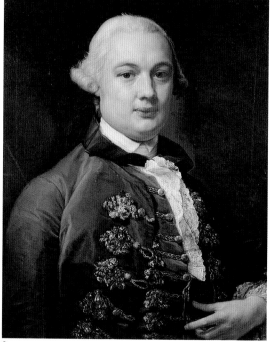

3

Spanish School

There are only nine Spanish paintings in the Gallery, making a coherent survey of this school impossible. However the quality of these works is high and the major figures of the *Siglo de Oro* of Spanish seventeenth-century painting, El Greco, Velázquez and Zurbarán, are represented by outright masterpieces.

El Greco was born in Crete and trained in Italy under Titian, then went to Spain in about 1576 and settled in Toledo for the rest of his life. There are few El Greco in British public collections and Edinburgh is fortunate enough to have two. Many of El Greco's works were executed for religious communities and his *Saviour of the World* (c1600) is typical of his visionary and intensely personal interpretation of a sacred theme. The picture perhaps belonged to an 'Apostalado', a series of thirteen canvases representing Christ and the Apostles (of which there is a later series in Toledo Cathedral). *Fábula* represents a rare departure by El Greco from religious subject matter, though its precise meaning remains obscure. It is likely, however, that the painting contained some warning of the moral consequences of 'playing with fire'. There are three versions of the composition of which this is the latest and most brilliant in handling.

It was at the end of the sixteenth century that the rise of *genre* painting in Spain began, later to be reflected in the *bodegones* of the young Velázquez, of which *Old woman cooking eggs* is a prime example. Velázquez became court portrait painter to Philip IV after settling in Madrid in 1623, but there was also still a demand for religious painting produced by artists such as Francisco di Zurbarán, Velázquez's senior by a year and his lifelong friend. Zurbarán's *Virgin of the Immaculate Conception* (possibly painted for a monastery in Jerez) exists in at least eight versions; the subject was a favourite one in Seville and in the next generation Murillo painted it a number of times.

The eighteenth century is marked by only one painting in the Gallery, Francisco de Goya's *El Medico*. This was one of the eleven designs made for tapestries in the palace of El Pardo, near Madrid, and was intended as an overdoor. The title is taken from Goya's own description of the work but interpretations of the subject matter differ, although it has been suggested that the leafless tree and burning coal point to an allegory of Winter.

Spanish painting was highly popular in Scotland, particularly in the last century, influencing Scottish artists such as Wilkie, and the Galleries' collection of Spanish paintings, though small, is part of that tradition.

1
**Domenikos Theotokopoulos, called
El Greco**
Kameia 1541 – 1614 Toledo
The Saviour of the World c1600
Canvas, 73 × 56.5 cm
Purchased 1952, NGS 2160

2
**Domenikos Theotokopoulos, called
El Greco**
Kameia 1541 – 1614 Toledo
Fábula 1580s
Canvas, 67.3 × 88.6 cm
Accepted in lieu of tax and with the
aid of the NMHF and the NACF 1989,
NGS 2491

3
Francisco de Zurbarán
Fuente de Cantos 1598 – 1644 Madrid
The Immaculate Conception c1639-40
Canvas, 255.5 × 177 cm
Transferred from the Royal Institution
1859, NGS 340

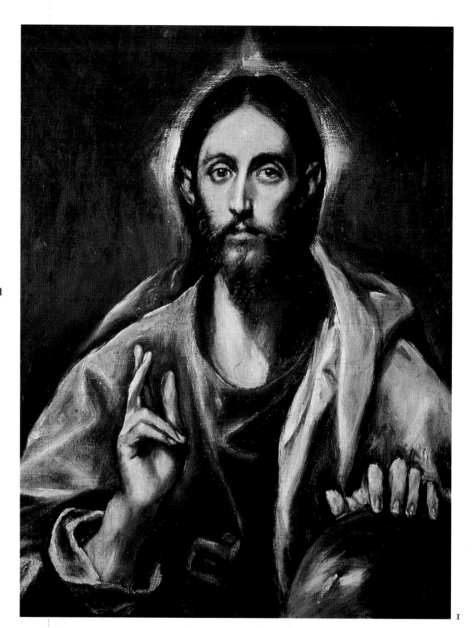

1

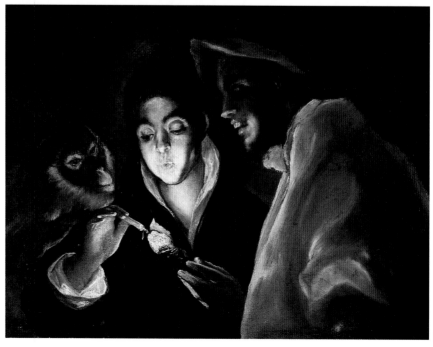

2

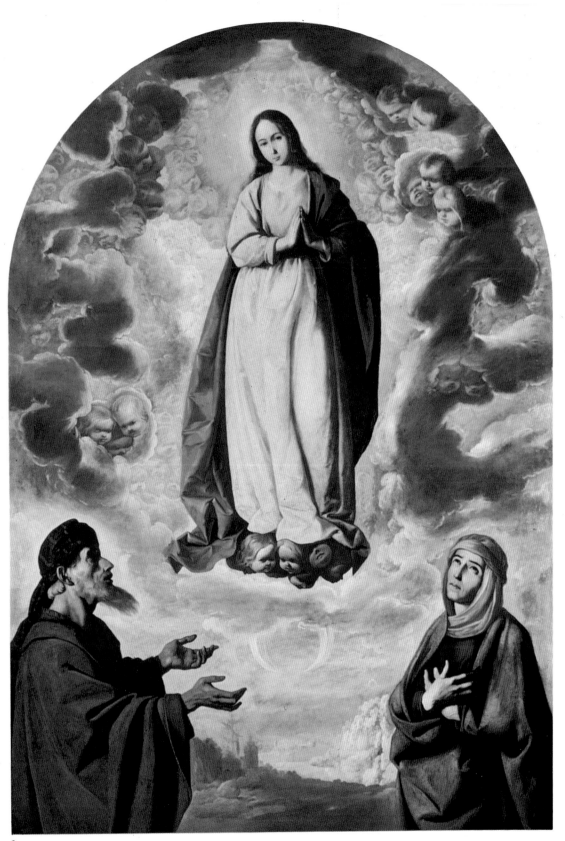

3

1
Diego Velázquez de Silva
Seville 1599 – 1660 Madrid
Old woman cooking eggs 1618
Canvas, 99 × 117 cm
Purchased with the aid of a Treasury
Grant and the NACF 1955, NGS 2180

Velázquez was born in Seville and
trained principally in the academy of
Francisco Pacheco between 1613 and
1618. Here he specialized in paintings
of everyday life, kitchen and tavern
scenes known as *bodegones* of which
this is an example. This subject matter
was popular with young painters in
Seville at the time, who were inspired
by engravings from Holland, particu-
larly those after Pieter Aertsen. Con-
temporary Spanish picaresque
literature also seems to have been
influential upon such subject matter.
Inscribed 16(1)8, this painting is one
of the earliest of Velázquez's surviving
dated works. The old woman here is
the same model as that found in
Martha and Mary in the National Gal-
lery, London, also dated 1618.

2
Francisco José de Goya
Fuendetodos 1745/6 – 1828 Bordeaux
'El Médico' 1776-80
Canvas, 95.8 × 120.2 cm
Purchased 1923, NGS 1628

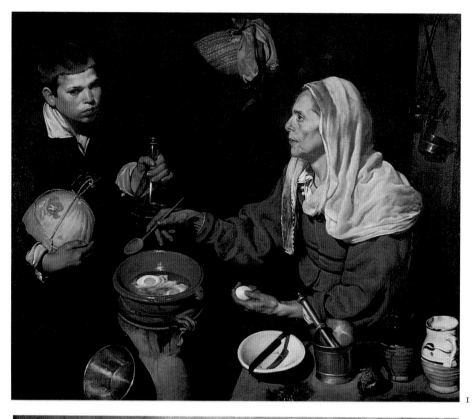

1

2

Flemish and Dutch Schools

Commerce and merchant enterprise ensured close links between Scotland and the Low Countries from an early date and it is to this fact that we owe the existence of Hugo van der Goes's *Trinity* altarpiece (on loan from Her Majesty the Queen), which is certainly the most precious survival of fifteenth-century painting in Scotland. The probable commissioner of the panels, Edward Bonkil, who was the first Provost of the Collegiate church of the Holy Trinity in Edinburgh, had a brother who was one of the leading Scottish merchants settled in Bruges, and Bonkil may have visited and sat to Van der Goes there. Van der Goes, the most important Ghent painter in the period after Jan van Eyck, spent his last years in the Rode Klooster near Brussels, which was run by an Augustinian order which also had charge of Holyrood Abbey in Edinburgh, and it may well be that through such contacts Van der Goes' fame reached Scotland and the superb panels came to be commissioned.

Later and less dramatic is the peacefully pious work of Gerard David as demonstrated in his *Three episodes from the life of St Nicholas*. David was the last master of the Bruges school and painted in the earlier fifteenth-century tradition of Van Eyck and Van der Goes. However, as the prosperity of Bruges waned and Antwerp took its place as one of the richest and most cosmopolitan of European cities, so too was the art of painters such as David superseded by the new, Italianate, Antwerp style. It was to that city that Quentin Massys travelled from his native Louvain to work before the end of the fifteenth century and to become Antwerp's leading painter. His *Portrait of a man* shows the Italian Renaissance acting upon the northern tradition. The classical arches and pillars in the picture combine with a mountainous landscape of a kind that appeared in the background of Leonardo da Vinci's paintings and would return in the work of Pieter Breughel or in Paul Bril's *Landscape with figures*. Rubens's period in Italy (1600-08) was crucial to his development. His *Feast of Herod* echoes Veronese's sumptuous scenes, but is interpreted with unflinching Flemish realism, and it was Rubens's genius to make of such differing traditions a convincing and inventive synthesis. Rubens's most gifted pupil, Anthony van Dyck, also spent important formative years in Italy (1623-27) where he developed a style which, though indebted to his master, was ideally suited to the portrayal of the Italian ruling classes in its remote dignity and calm elegance, so clearly seen in his 'Lomellini family'. The idealized figure of his *St Sebastian*, unsullied even by arrows, also points to the influence of the grand tradition of Italian history and religious painting upon the predominantly Catholic Flemish taste of the period. The Union of Utrecht and the secession of the Seven Northern Provinces had forced many Protestants north from the southern Catholic provinces for fear of persecution, particularly after the Spanish took Antwerp in 1585. Whilst it would be wrong to suggest that the division was total, it was sufficiently marked to make the distinction between Flemish and Dutch art discernible from this period, though there was a continued exchange of ideas.

Frans Hals, the first of the great Dutch figure painters, was born in Antwerp but spent most of his life in Haarlem (where Rubens visited him in 1624). His deft brushwork and virtuoso handling of paint in pictures such as *Verdonck* assured Hals his place in Dutch portraiture. Rembrandt's *Woman in bed* is also probably a portrait, perhaps of Geertje Dircx, but is almost certainly charged with a religious meaning, possibly showing Sarah waiting for her bridegroom (Tobit 7, 1–4). In his *Self-portrait* painted the year after his financial collapse in 1656, Rembrandt achieves a study of intense and intimate introspection. Jan Vermeer of Delft was best known for his domestic interiors but is represented in the collection by *Christ in the house of Martha and Mary*, a biblical scene in grand format which is probably his earliest known work. Although religious painting and history pieces were still in demand, the Treaty of Utrecht establishing the Dutch Reformed Church as the state religion of the Northern provinces encouraged artists to paint predominantly secular works.

Landscape was also extremely popular in Holland at this time and is well represented in the Gallery. In Philips Koninck's *Extensive landscape* the imaginary is combined with a more natural vista in a broad panorama. The high viewpoint he uses is also employed by Jacob van Ruisdael in his magnificent *Banks of a river* from the Torrie collection. The restricted palette of the previous generation of artists, such as Jan van Goyen, here gives way to the fuller, richer colours of Dutch landscape in the third quarter of the century. This is especially so in Aelbert Cuyp's golden *View of the Valkhof, Nijmegen*, suffused by the strong southern light of the Dutch Italianate tradition. Although some landscape artists made outdoor sketches, there is no evidence to suggest they painted directly from nature and Hobbema's *Wooded landscape* is a good example of such invented views. Even Pieter Saenredam's breathtaking *Interior of St Bavo's Haarlem* (for which he made extremely precise perspectival studies), distorts the dimensions of the pillars and vault to increase the monumental grandeur of the building.

Hugo van der Goes
Ghent *c*1440 – 1482 near Soignies
The Trinity Altarpiece *c*1478-79, left
wing, obverse:
James III, King of Scots accompanied by
his son James(?) presented by St Andrew
Panel, 202 × 100.5 cm
On loan from Her Majesty the Queen

Hugo van der Goes
Ghent *c*1440 – 1482 near Soignies
The Trinity Altarpiece *c*1478-79, right
wing, obverse:
Margaret of Denmark, Queen of Scots
presented by St George (?)
Panel, 202 × 100.5 cm
On loan from Her Majesty the Queen

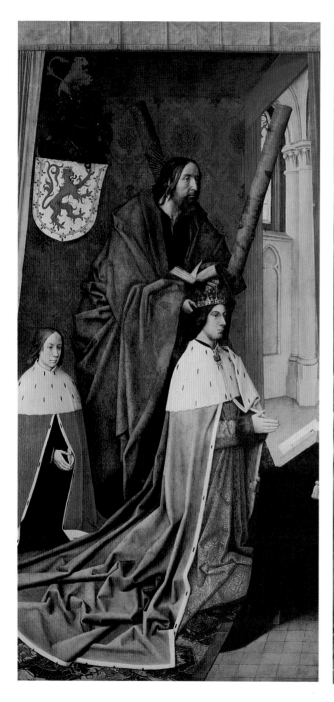

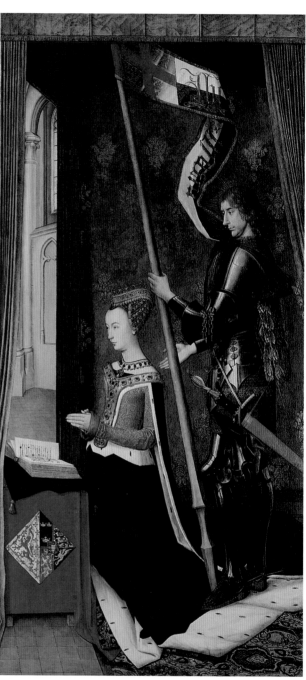

While the identity of the sitters is
shown by their coats of arms, the
panels are thought to have been
painted for the Collegiate Church of
the Holy Trinity in Edinburgh, founded
by the mother of King James III of
Scotland, Mary of Guelders. The panels

Hugo van der Goes
Ghent *c*1440 – 1482 near Soignies
The Trinity Altarpiece *c*1478-79, left
wing, reverse:
The Holy Trinity of the Broken Body
Panel, 202 × 100.5 cm
On loan from Her Majesty the Queen

Hugo van der Goes
Ghent *c*1440 – 1482 near Soignies
The Trinity Altarpiece *c*1478-79, right
wing, reverse:
Edward Bonkil, First Provost of the Colle-
giate Church of the Holy Trinity and two
angels
Panel, 202 × 100.5 cm
On loan from Her Majesty the Queen

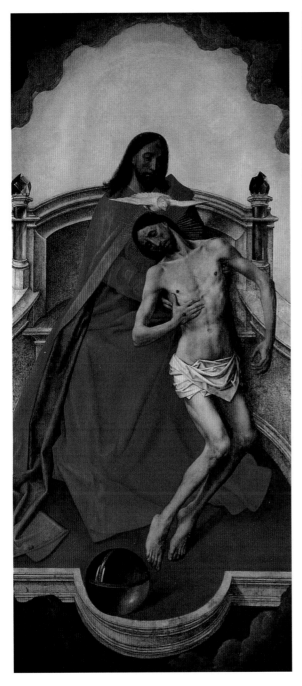

were perhaps commissioned by the
first Provost of the church, Edward
Bonkil, between 1473 and 1478. The
two wings may have flanked a central
panel which was perhaps destroyed at
the Reformation, although it has also
been suggested that the wings were
intended to be used as organ shutters
on their own. The panels relate closely
in style to the Portinari altarpiece,
which is Van der Goes's only 'authen-
ticated' work, now in the Uffizi,
Florence.

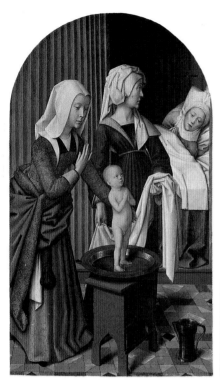 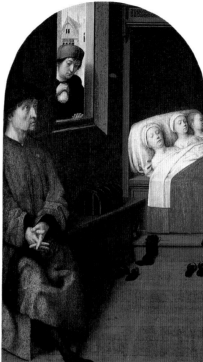 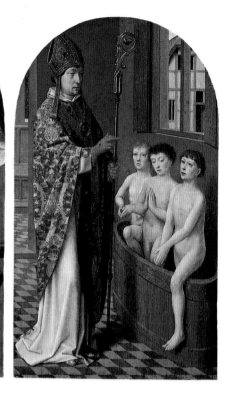

Gerard David

Oudewater 1450/60 – 1523 Bruges

Three episodes from the life of St Nicholas

Three panels, each 55.9 × 33.7 cm
Purchased with the aid of the NACF
and a Treasury Grant 1959, NGS 2213

Gerard David worked in Bruges from
1484 and became the principal painter
of the city after Memling's death in
1494. Though contemporary with
artists working in the Renaissance
style, such as Massys in Antwerp,
David was most strongly influenced by
art of the earlier fifteenth century. The
panels show three episodes from the
life of St Nicholas of Myra. The first (on
the left) shows the infant saint praying
on the day of his birth to give thanks
to God. The second shows how
Nicholas secretly supplied dowries for
the daughters of an impoverished
nobleman, while the third shows how,
as Bishop of Myra, he resuscitated
three boys who had been salted down
as meat in time of famine. The panels
were part of a large altarpiece showing
*St Nicholas, St Anne with the Virgin and
Child, and St Anthony of Padua,* now in
the National Gallery, Washington.
Three panels showing scenes from the
life of St Anthony, now in Toledo,
Ohio, probably combined with those of
St Nicholas to form a predella for the
altarpiece.

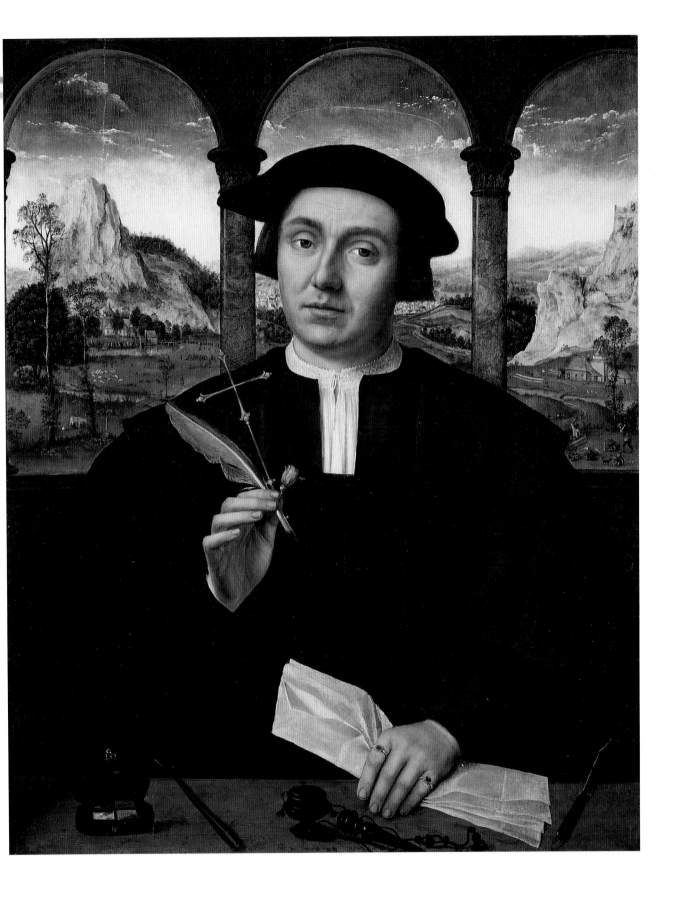

Quentin Massys
Louvain 1465/6 – 1530 Antwerp
Portrait of a man c 1510-20
Canvas, 80 × 64.5 cm
Received 1965, NGS 2273

1
Peter Paul Rubens
Siegen 1577 – 1640 Antwerp
The Feast of Herod c1633-38
Canvas, 208 × 264 cm
Purchased 1958, NGS 2193

2
Paul Bril
Antwerp 1554 – 1626 Rome
Fantastic landscape 1598
Copper, 21.3 × 29.2 cm
Mrs Nisbet Hamilton Ogilvy of Biel
bequest 1921, NGS 1492

3
Peter Paul Rubens
Siegen 1577 – 1640 Antwerp
The Reconciliation of Jacob and Esau
c1624-26
Panel, 42.5 × 40.3 cm
Allocated by the Treasury 1980,
NGS 2397

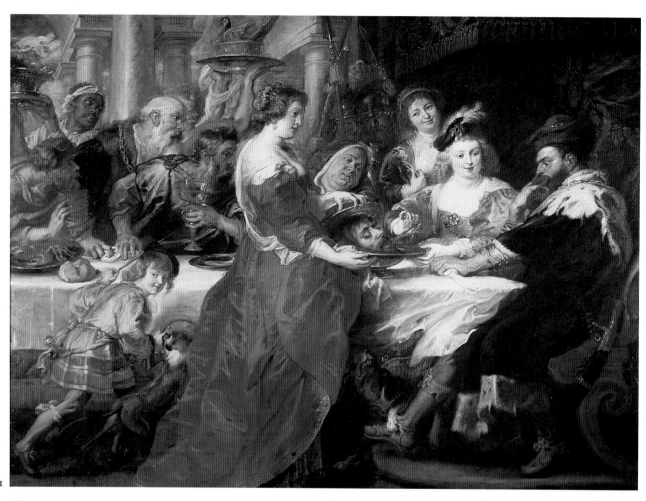

1

2

3

Sir Anthony Van Dyck
Antwerp 1599 – 1641 London
St Sebastian bound for martyrdom
*c*1621/3
Canvas, 226 × 160 cm
Transferred from the Royal Institution
1858, NGS 121

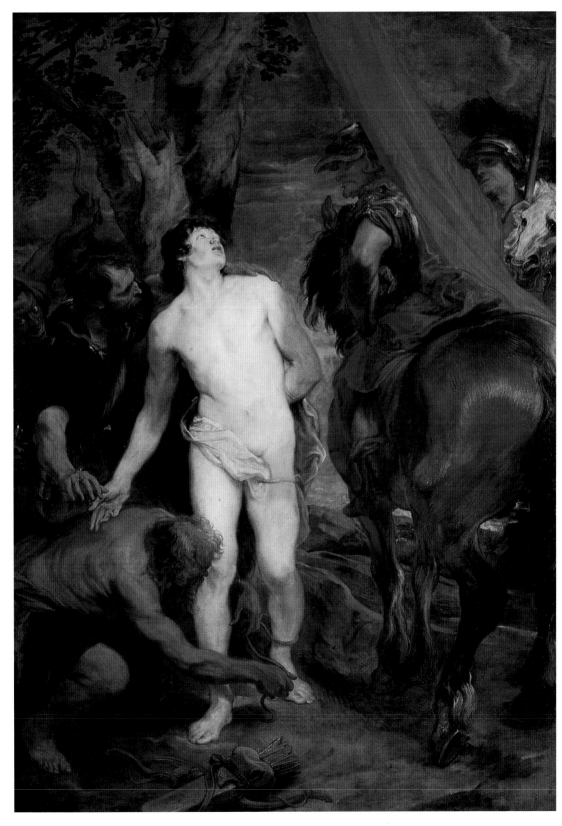

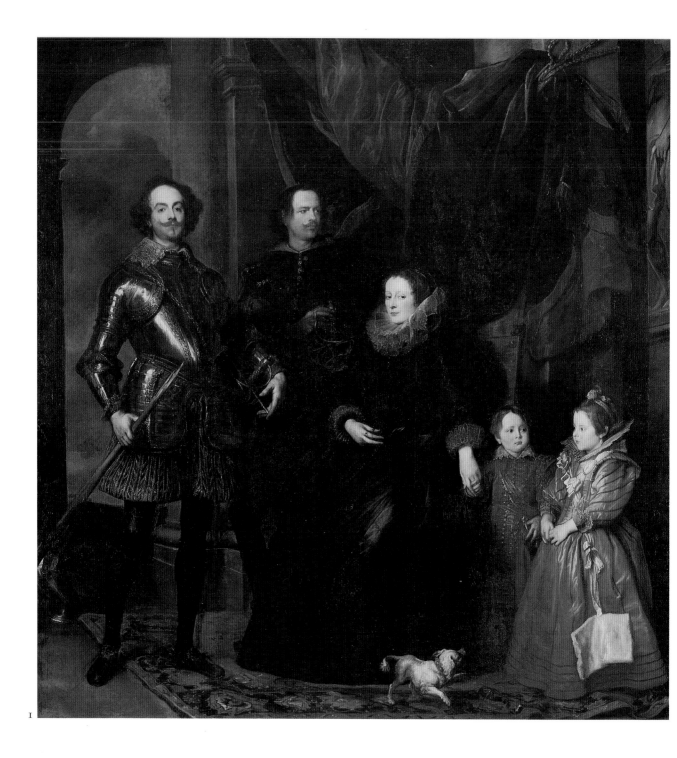

1

1
Sir Anthony Van Dyck
Antwerp 1599 – 1641 London
'The Lomellini Family', c1623-27
Canvas, 269 × 254 cm
Transferred from the Royal Institution
1858, NGS 120

2
Frans Hals
Antwerp c1580 – 1666 Haarlem
A Dutch gentleman, c1643-45
Canvas, 115 × 86.1 cm
Rt Hon William McEwan gift 1885,
NGS 691

3
Frans Hals
Antwerp c1580 – 1666 Haarlem
A Dutch lady, c1643-45
Canvas, 115 × 85.8 cm
Rt Hon William McEwan gift 1885,
NGS 692

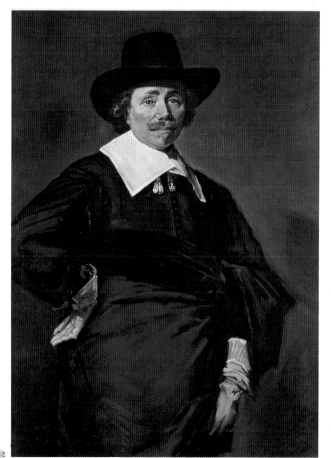

2

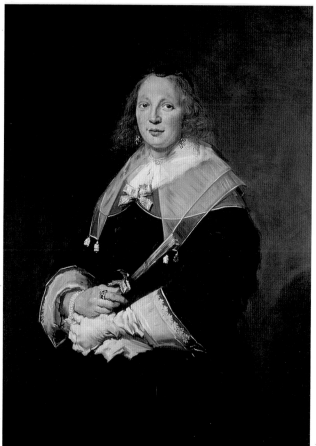

3

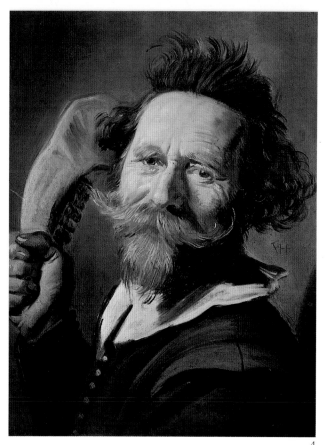

4

4
Frans Hals
Antwerp *c*1580 – 1666 Haarlem
*Verdonck, c*1627
Panel, 46.4 × 35.5 cm
John J Moubray of Naemoor gift 1916,
NGS 1200

Rembrandt Harmensz. van Rijn
Leiden 1606 – 1669 Amsterdam
Woman in a bed
Canvas, 81.1 × 67.8 cm
Rt Hon William McEwan gift 1892,
NGS 827

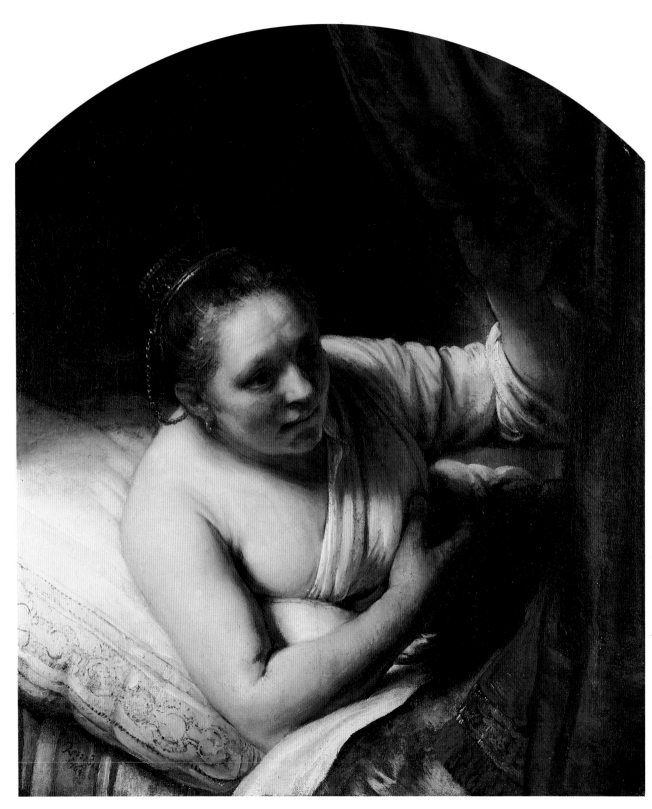

48

Rembrandt Harmensz. van Rijn
Leiden 1606 – 1669 Amsterdam
Self-portrait aged 51 1657
Canvas, 52.5 × 43 cm
Duke of Sutherland loan 1946

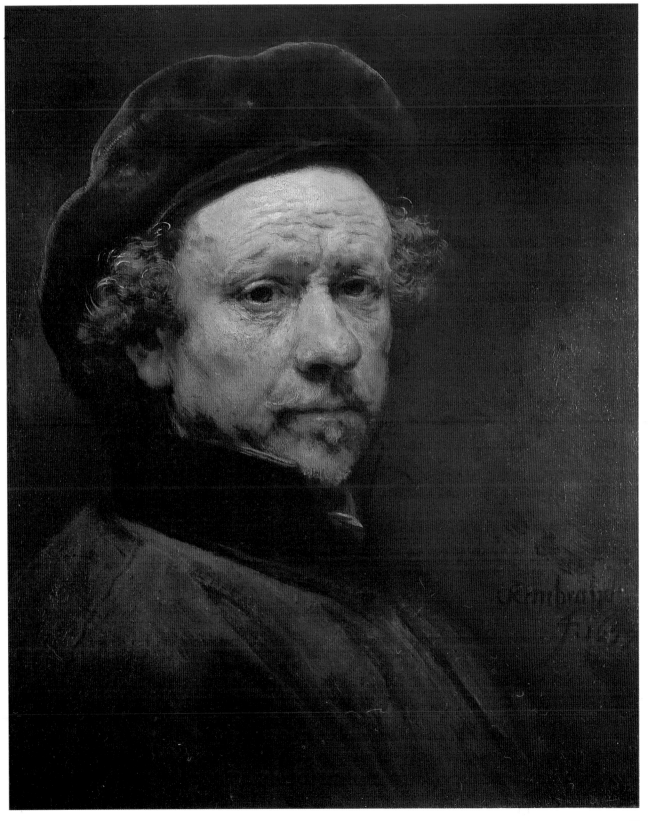

1
Gerrit Dou
Leiden 1613 – 1675 Leiden
Interior with a young violinist 1637
Panel, 31.3 × 23.7 cm
Purchased with the aid of the NHMF,
NGS 2420

2
Jan Lievens
Leiden 1607 – 1675 Amsterdam
Young man c1628-30
Canvas, 112 × 99.4 cm
Purchased 1922, NGS 1564

3
Pieter Jansz. Saenredam
Assendelft 1597 – 1665 Haarlem
Interior of St Bavo's Church at Haarlem
1648
Panel, 174.8 × 143.6 cm
Purchased with the aid of the NHMF,
the NACF and the Pilgrim Trust 1982,
NGS 2413

St Bavo's, or the Great Church, is
one of the finest Gothic buildings in the
Netherlands. It was begun in 1397,
after the great fire at Haarlem. This
'portrait' of the church shows the view
from the north side of the choir, look-
ing west down the nave, which is vir-
tually unchanged today. Saenredam
made precise perspectival studies upon
which the painting is based, but subtly
manipulated the building's real dimen-
sions to make the scale still more
impressive. The picture was presented
to Charles II of England by the Dutch
Government in 1660 and is the largest
of Saenredam's surviving works.

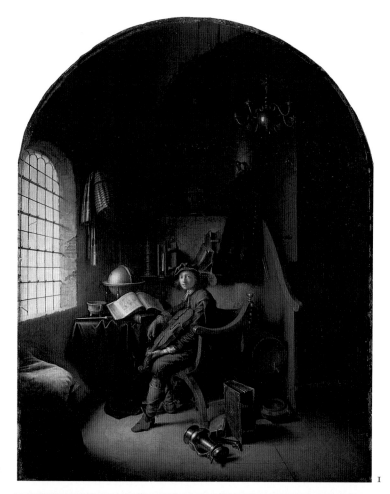

I

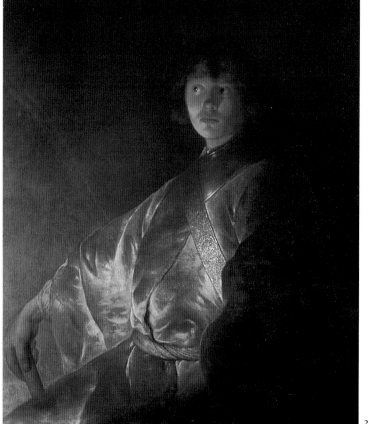

2

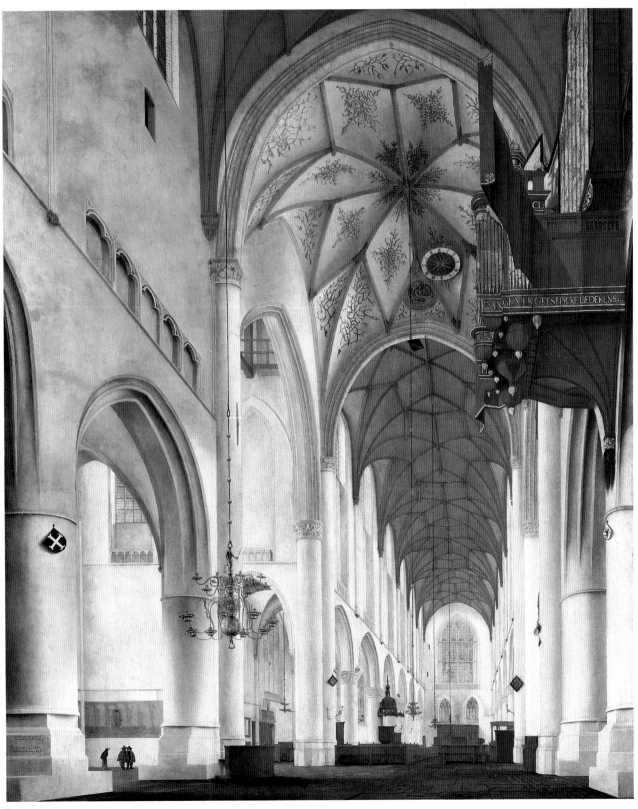

3

1
Aelbert Cuyp
Dordrecht 1620 – 1691 Dordrecht
Landscape with a view of the Valkhof,
Nijmegen c1655–60
Canvas, 113 × 165 cm
Purchased with the aid of the NACF
1972, NGS 2314

1

2
Jacob van Ruisdael
Haarlem c1628 – 1682 Haarlem
Banks of a river 1649
Canvas, 134 × 193 cm
Torrie bequest, Edinburgh University
loan 1845

3
Meindert Hobbema
Amsterdam 1638 – 1709 Amsterdam
*Wooded landscape c*1662-63
Canvas, 93.7 × 130.8 cm
Purchased with the aid of the NACF
and National Heritage Purchase Grant
(Scotland) 1979, NGS 2377
 With its contrast between the dark-
ened foreground and illuminated
middle distance, this is a mature exam-

ple of the picturesque woodland scenes
in which Hobbema specialized. His
work was much influenced by his
friend and master Jacob van Ruisdael,
then Amsterdam's most famous land-
scape artist. Hobbema seems to have
been his pupil shortly before 1660, but
it is possible that his training started
elsewhere, as he would already have
been 22 years old in that year. The
development of Hobbema's style
during his most productive years
(c1658-71) is charted by several dated
pictures, but there is still much confu-
sion about his work in the 1670s, and
his *Avenue at Middelharnis* of 1689
(National Gallery, London) is one of
only two pictures known to have been
painted in the 1680s.

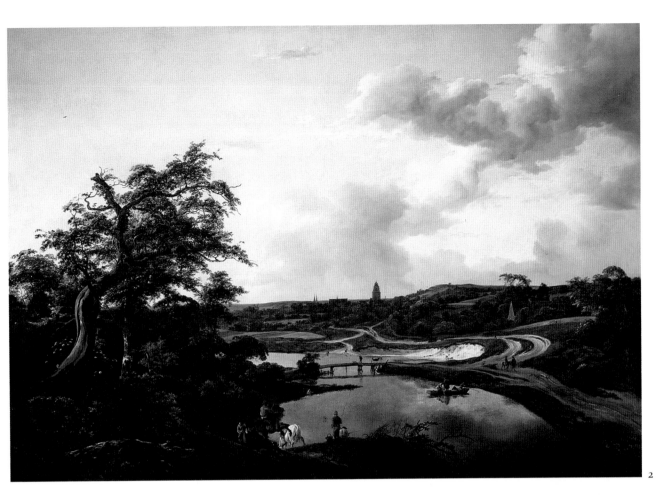

2

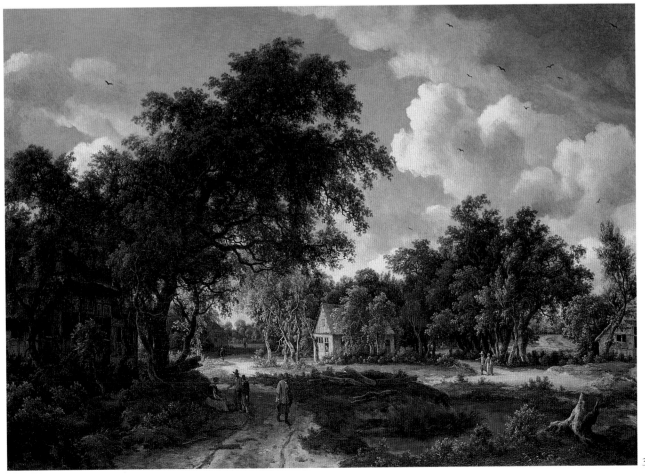

3

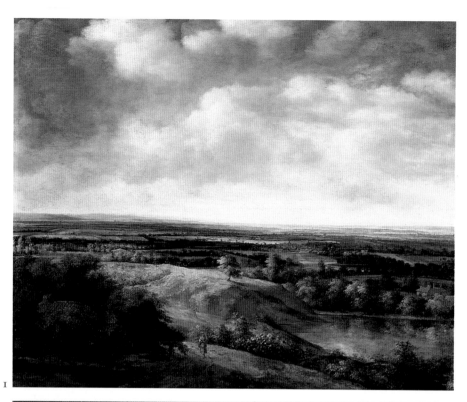

1

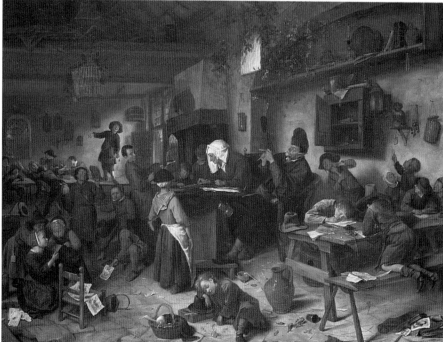

2

1
Philips Koninck
Amsterdam 1619 – 1688 Amsterdam
Extensive landscape 1666
Canvas, 91 × 11.8 cm
Purchased 1986, NGS 2434

2
Jan Steen
Leiden 1625/6 – 1679 Leiden
School for boys and girls c1670
Canvas, 81.7 × 108.6 cm
Purchased with the aid of the NHMF
1984, NGS 2421

3
Jan Vermeer
Delft 1632 – 1675 Delft
Christ in the house of Martha and Mary
c1654-55
Canvas, 160 × 142 cm
Coats gift 1927, NGS 1670

The subject is taken from Luke 10,
38-42, where Mary's eagerness to sit
listening to Christ is praised by Him,
while her sister Martha's bustling hos-
pitality prevents her from paying
attention to Christ's words. This is the
largest known picture by Vermeer and
also probably the earliest (c1654-55),
judging by microscopic analysis of pig-
ments used. At this stage Vermeer was
working in a style, deriving ultimately
from Caravaggio, which he must have
developed from the pictures of Ter-
brugghen and the Caravaggesque
painters of Utrecht. The composition is
signed in monogram and may be based
on an engraving by G van Velden after
Otto van Veen of c1597-98.

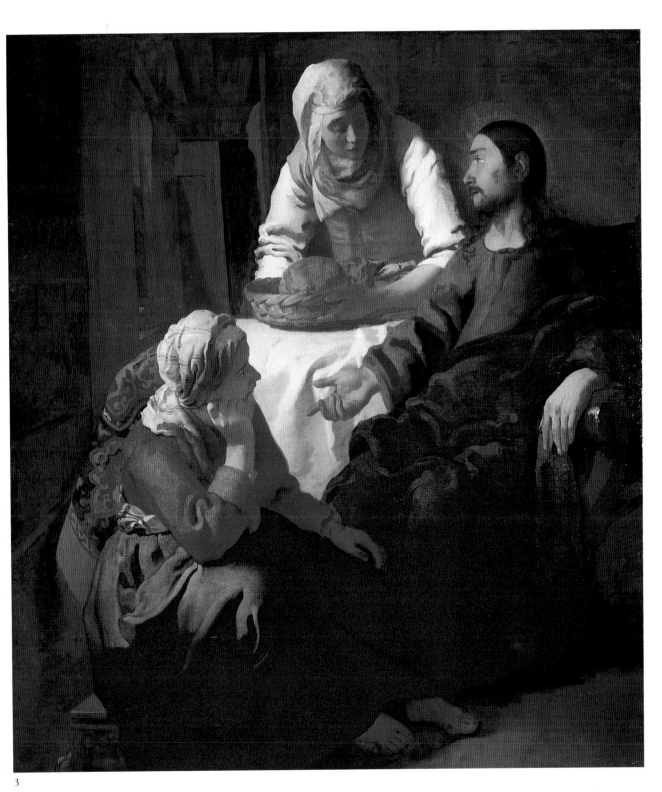

3

1
Vincent Van Gogh
Zundert 1853 – 1890 Auvers-sur-Oise
Olive trees 1889
Canvas, 51 × 65.2 cm
Purchased 1934, NGS 1803

2
Vincent Van Gogh
Zundert 1853 – 1890 Auvers-sur-Oise
Orchard in blossom 1888
Canvas, 54 × 65.2 cm
Sir Alexander Maitland gift 1960, NGS
2217

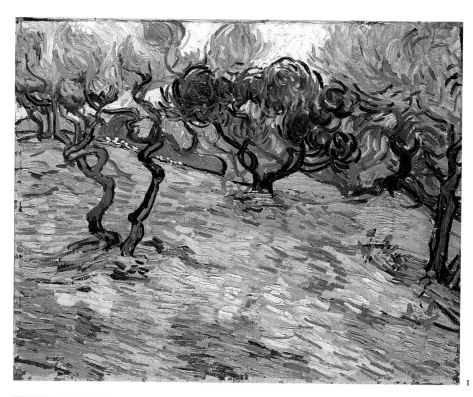

1

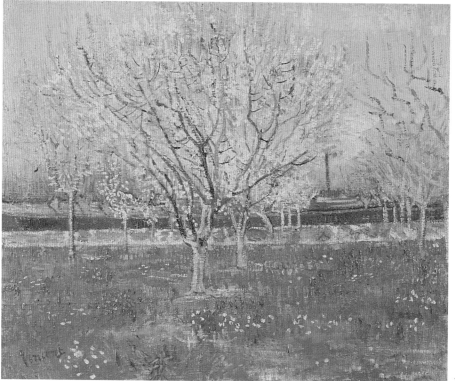

2

French School

In the Middle Ages and the Renaissance, French art was predominantly a courtly one, characterized by exquisite sculpture, *objets d'art* and manuscript illumination. The greatest of these courts was undoubtedly that of François I (died 1547), who enticed the ageing Leonardo da Vinci and other major Italian artists to his palace at Fountainebleau, and for whom Jean Clouet (whose *Mme de Canaples* is in the Gallery) also painted.

During the seventeenth century, under Louis XIV, French society and government were radically centralized and an Academy of Painting and Sculpture was established in Paris in 1648. Eighteen years later, in 1666, a branch of the French Academy was established in Rome so artists received training both at home and abroad. Two of the greatest French artists of this period spent almost their entire careers in Rome. Claude Lorrain's idyllic landscapes (in the Gallery, *Landscape with Apollo and the Muses*) celebrated Rome and the surrounding campagna. They were particularly popular with British collectors in the eighteenth century. Nicolas Poussin, with whom Claude is often contrasted, brought an intellectually vigorous approach to his own landscapes and to his mythological and religious paintings. His second set of the *Seven Sacraments* in the Gallery is one of the most profound achievements in Western art.

The Rococo period in the early eighteenth century brought a complete change. It was a light and playful art ushered in by the *fêtes galantes* of Antoine Watteau (his *Fêtes Vénitiennes* is in the Gallery), which continued until the late works of Madame de Pompadour's favourite painter, François Boucher (*The offering to the country girl*). By

this time, however, the sentiments embodied in the works of Jean Baptiste Greuze held sway (seen here is *Girl with dead canary*). These were rapidly succeeded by the sterner moralities of Neo-classicism which so conveniently continued into the age of Empire under Napoleon (Baron Gérard, *Madame Mère*).

French artists had enjoyed an official forum for their work since 1667, when the first Salon of the Academy was held in the Louvre. Given the academic hierarchy of the Academy, it is perhaps surprising to find that the still-life painter Chardin (*Vase of flowers*) at one time held an official appointment with responsibilities for arranging the hanging of the Salon.

In the post-Revolutionary period the Academy was replaced by the School of Fine Arts. The nineteenth century saw a growing reaction against official schools and Salons, however. They were challenged by the *ateliers* of certain masters and by one-man exhibitions (for instance Courbet's). Finally, in 1874, the Impressionists staged their first exhibition. Altogether there were eight Impressionist shows but of the major figures such as Monet, Degas, Sisley and Renoir, only Pissarro contributed to all of them. Building on the achievements of the Impressionists were artists such as Cézanne, Gauguin (*The Vision after the Sermon*) and Van Gogh. Post-Impressionism, the title under which these artists have sometimes been loosely grouped, heralded a further move away from an accurate depiction of reality towards abstraction. In a number of important ways it prepared the way for the art of the twentieth century.

1
Jean Clouet
Brussels (?) 1485/90 – 1540/1 Paris (?)
Madame de Canaples (1502-58)
Panel, 36 × 28.5 cm
Eleventh Marquess of Lothian bequest
1941, NGS 1930

2
Corneille de Lyon
The Hague *c*1500-10 – *c*1575, active
in Lyons and Paris
Mary of Guise, (1515-60)
Panel, 22 × 15.1 cm
EP Jones gift 1950, SNPG 1558

3
Gaspard Dughet
Rome 1615 – 1675 Rome
Classical landscape with a lake
Canvas, 73 × 99.5 cm
Purchased 1973, NGS 2318

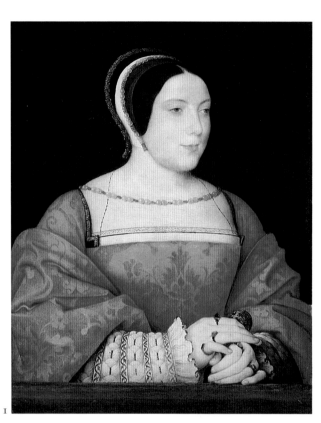

1

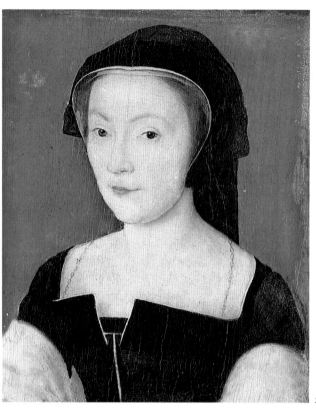

2

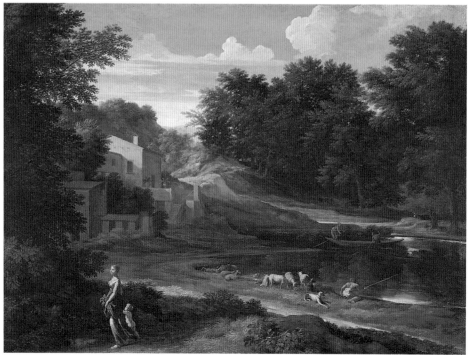

3

4
Claude Gellée, called Claude Lorrain
Chamagne 1600 – 1682 Rome
Landscape with Apollo and the Muses
1652
Canvas, 186 × 290 cm
Purchased 1960, NGS 2240

5
Nicolas Poussin
Les Andelys 1594 – 1665 Rome
Mystic Marriage of St Catherine c1629
Panel, 126 × 168 cm
Sir John Heathcoat Amory Bart
bequest 1973, NGS 2319

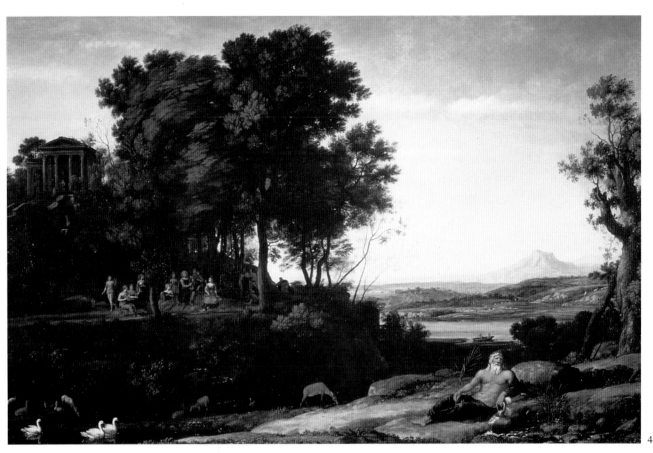

4

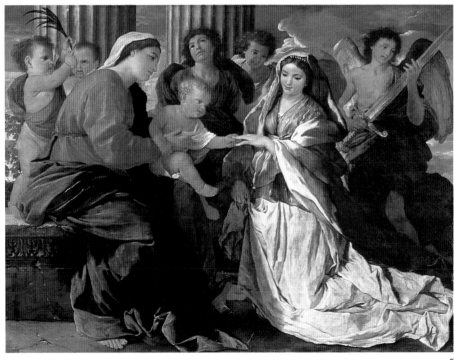

5

1

Nicolas Poussin
Les Andelys 1594 – 1665 Rome
The Seven Sacraments: Baptism 1646
Canvas, 117 × 178 cm
Duke of Sutherland loan 1946

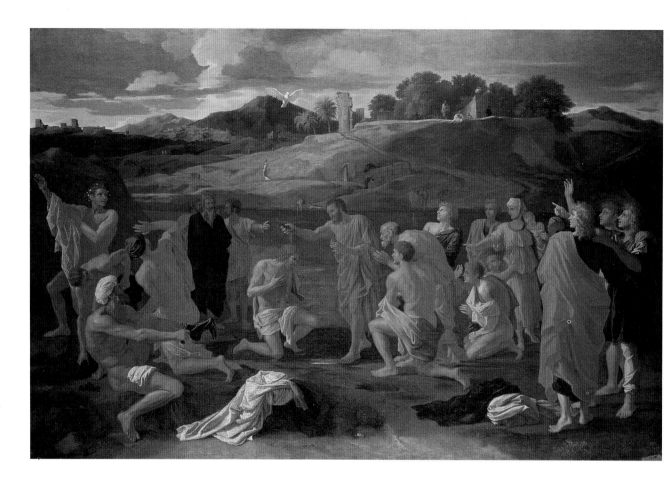

This series of paintings showing the Sacraments of the early Christian church was painted for Poussin's Parisian friend and patron Paul Fréart de Chantelou between 1644 and 1648. Poussin had moved to Rome in 1624 and, except for two years in Paris (1640-42), he remained in Rome for the rest of his life. It was there that Cassiano dal Pozzo, secretary to Cardinal Barberini, commissioned the first and smaller set of Sacraments, which was completed by 1642. Although initially intended as copies of these, the second set developed and refined the theme and was much praised by Bernini when he saw the works in 1665. Poussin portrayed these early Christian rites with precise archaeological detail; in their restraint and solemnity the *Sacraments* are far removed in spirit and style from the mainstream of Italian Baroque painting.

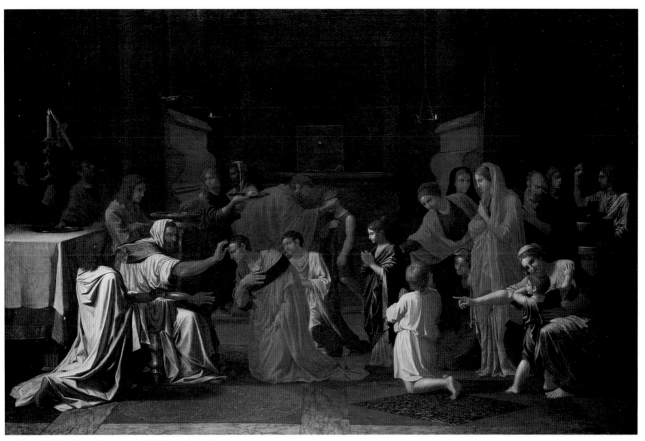

2 **Poussin** *The Seven Sacraments: Confirmation* 1645

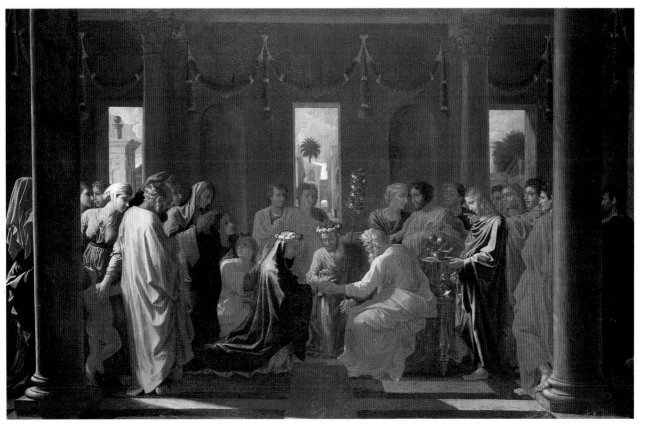

3 **Poussin** *The Seven Sacraments: Marriage* 1648

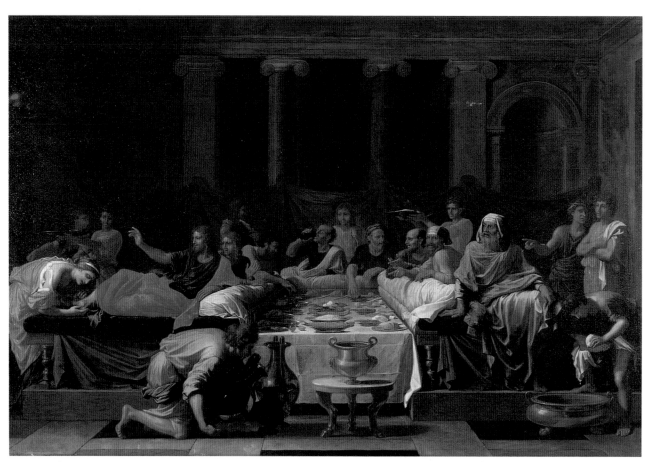

4 **Poussin** *The Seven Sacraments: Penance* 1646

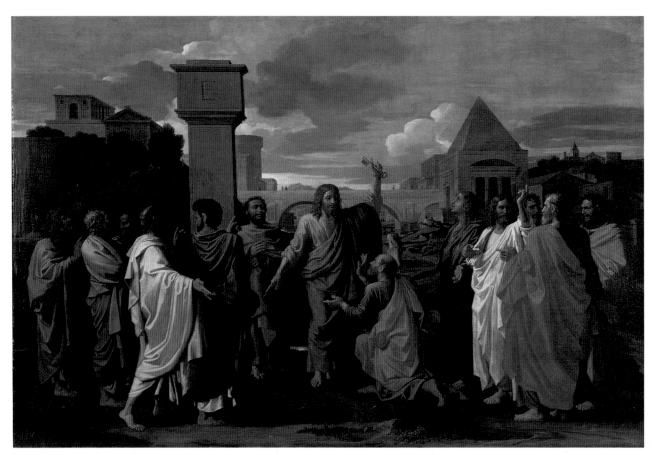

5 **Poussin** *The Seven Sacraments: Ordination* 1647

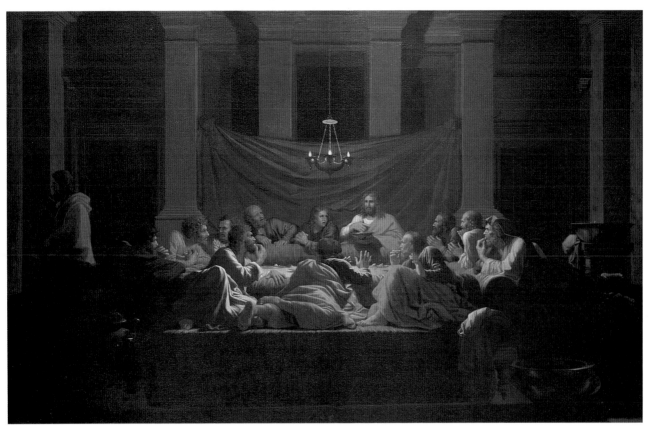

6 **Poussin** *The Seven Sacraments: Holy Eucharist* 1647

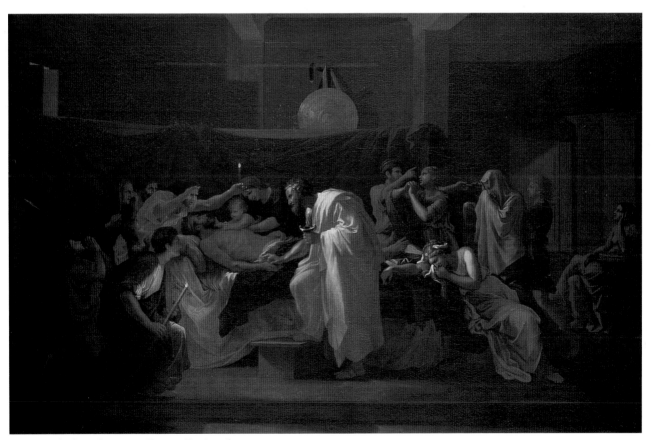

7 **Poussin** *The Seven Sacraments: Extreme Unction* 1644

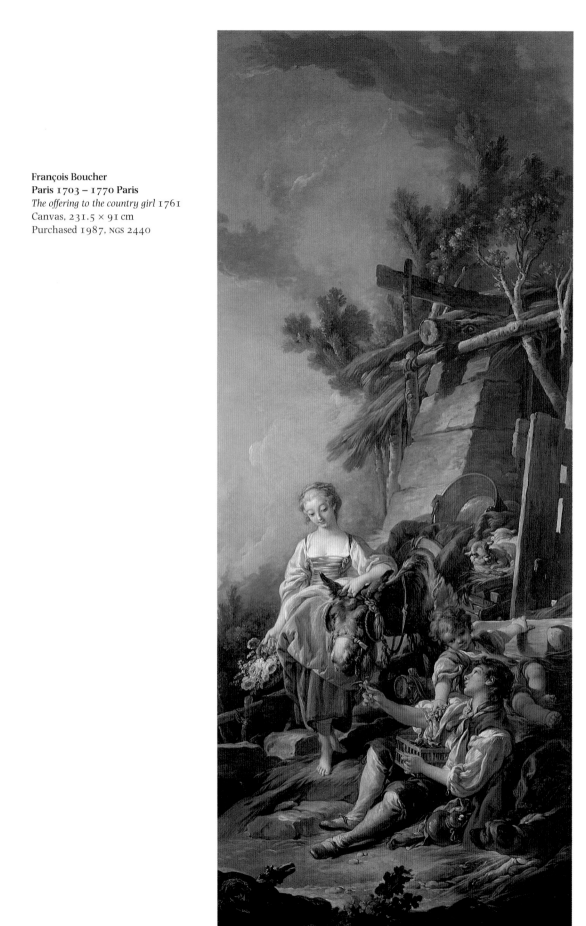

François Boucher
Paris 1703 – 1770 Paris
The offering to the country girl 1761
Canvas, 231.5 × 91 cm
Purchased 1987, NGS 2440

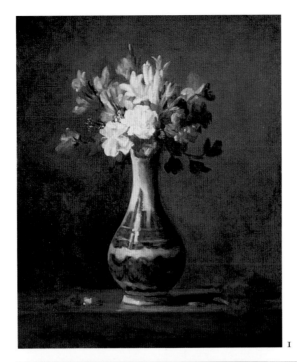

1
Jean-Baptiste Siméon Chardin
Paris 1699 – 1779 Paris
Vase of flowers c1760-63
Canvas, 45 × 37 cm
Purchased 1937, NGS 1883

2
Antoine Watteau
Valenciennes 1684 – 1721 Nogent
Fêtes Vénitiennes c1717-19
Canvas, 55.9 × 45.7 cm
Lady Murray of Henderland bequest
1861, NGS 439

1

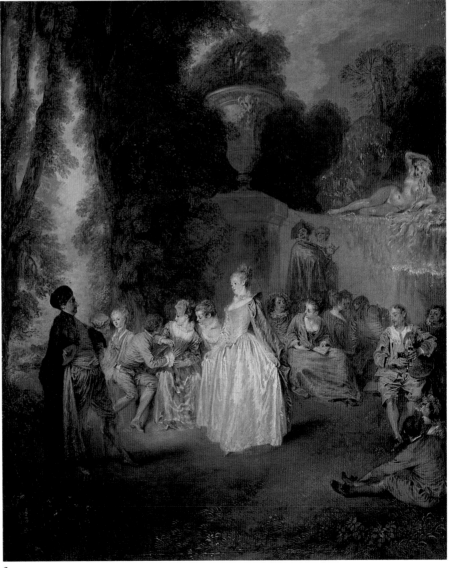

2

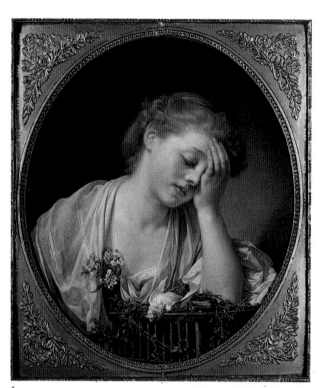

I

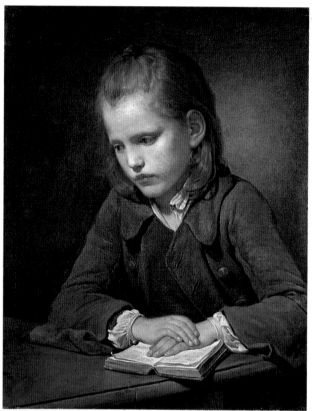

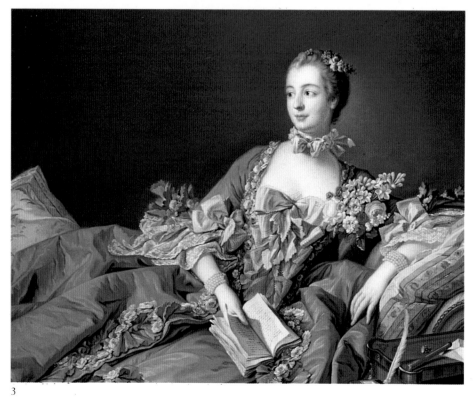

2

3

66

1
Jean-Baptiste Greuze
Tournus 1725 – 1805 Paris
Girl with dead canary
Canvas, 53.3 × 46 cm
Lady Murray of Henderland bequest
1861, NGS 435

2
Jean-Baptiste Greuze
Tournus 1725 – 1805 Paris
Boy with lesson book
Canvas, 62.5 × 49 cm
Lady Murray of Henderland bequest
1861, NGS 436

3
Circle of François Boucher
Paris 1703 – 1770 Paris
Madame de Pompadour
Canvas, 36.2 × 44.1 cm
Lady Murray of Henderland bequest
1861, NGS 429

4
François, Baron Gérard
Rome 1770 – 1837 Paris
Maria Laetitia Ramolino Bonaparte,
'Madame Mère' (1750-1837)
Canvas, 210.8 × 129.8 cm
Purchased with the aid of the NACF
1988, NGS 2461

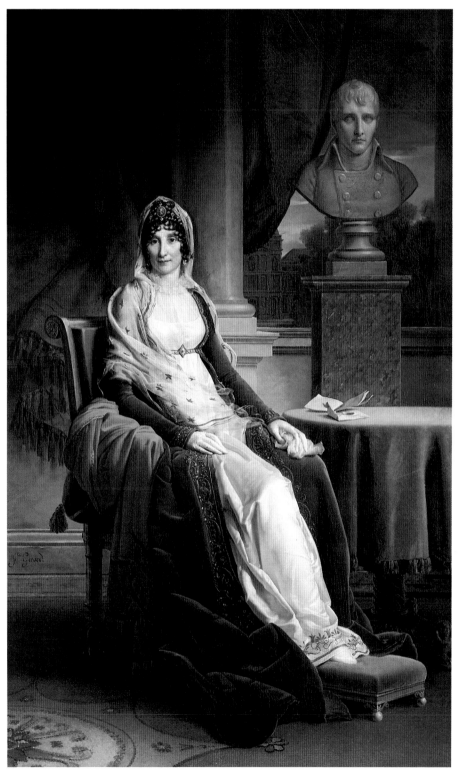

4

I

2

1
Jean-Victor Bertin
Paris 1767 – 1842 Paris
Classical landscape 1800
Canvas, 63.5 × 87 cm
Purchased 1988, NGS 2465

2
Camille Corot
Paris 1796 – 1875 Paris
Ville d'Avray c1823-25
Canvas, 46 × 34.9 cm
Purchased 1927 with the aid of A E
Anderson, NGS 1681
 Le Ville d'Avray, to the west of Paris,
was the site of the Corot family home.
This painting was probably executed
before Corot's first visit to Italy made
in 1825-28. The seated figure in the
composition is said to have been
painted by Diaz who made the
alteration with Corot's permission. By
his promotion of the *plein air* sketch
during his long career, Corot formed a
most important link between French
academic landscape and the Barbizon
School and the young Impressionists,
many of whom he knew well.

3
Eugène Delacroix
Charenton-St-Maurice 1798 – 1863
Paris
Arabs playing chess 1847
Canvas, 45.8 × 55 cm
Purchased 1957, NGS 2190

4
Gustave Courbet
Ornans 1819 – 1877 Tour de Peitz
The wave c1871
Canvas, 46 × 55 cm
Sir Alexander Maitland gift 1960, NGS
2233

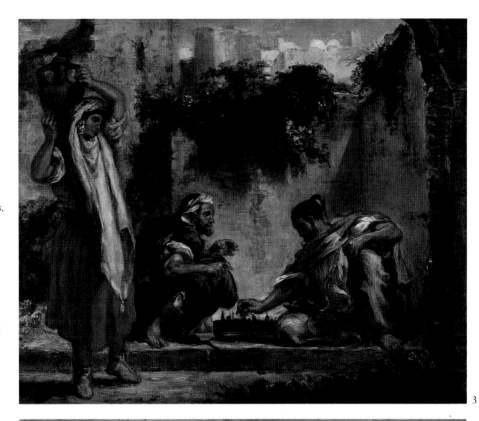

3

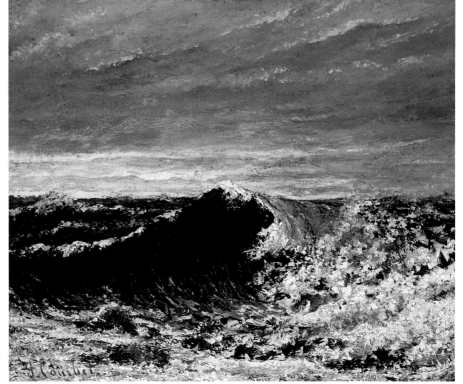

4

1
Camille Pissarro
Virgin Islands 1830 – 1903 Paris
The Marne at Chennevières c1864-65
Canvas, 91.5 × 145.5 cm
Purchased 1947, NGS 2098

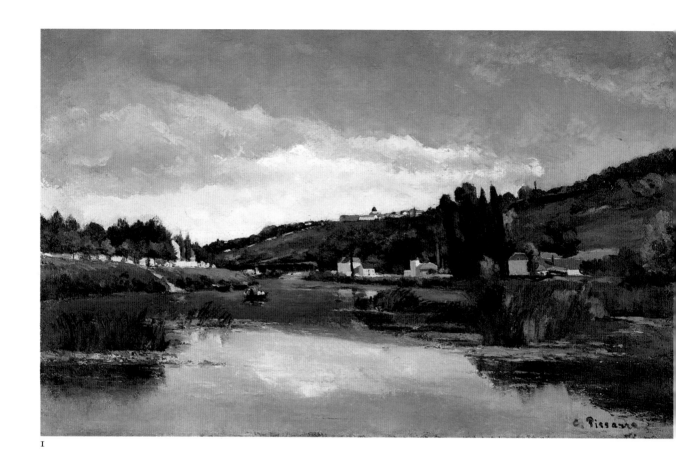

I

2
Camille Pissarro
Virgin Islands 1830 – 1903 Paris
Kitchen gardens at L'Hermitage, Pontoise
1874
Canvas, 54 × 65.1 cm
Mrs Isabel M Traill gift 1979, NGS
2384

3
Claude Monet
Paris 1840 – 1926 Giverny
Haystacks: snow effect 1891
Canvas, 65 × 92 cm
Sir Alexander Maitland bequest 1965,
NGS 2283

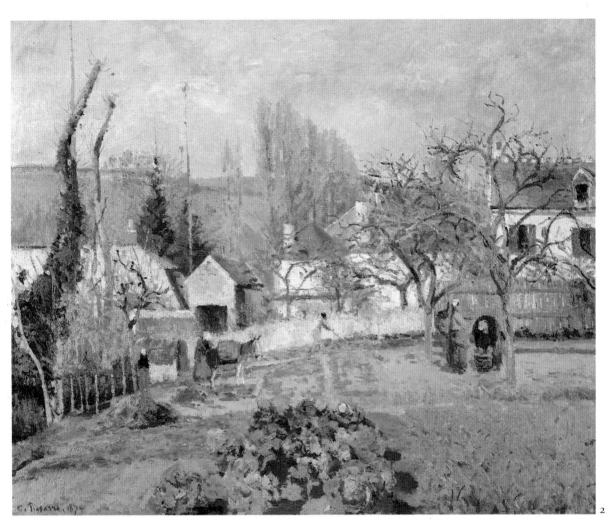

2

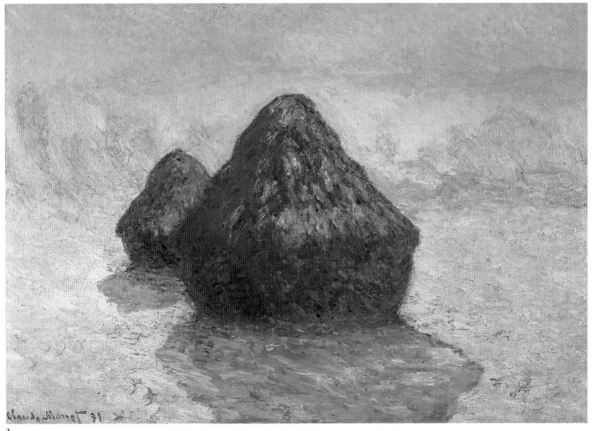

3

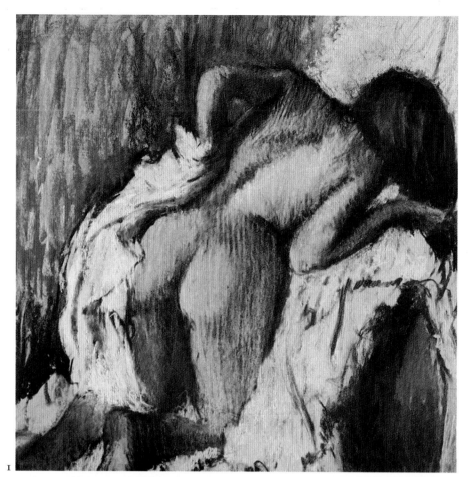

1

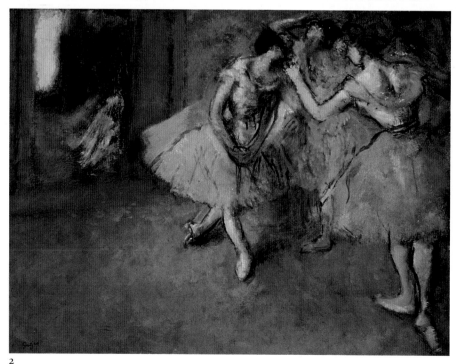

2

1
Edgar Degas
Paris 1834 – 1917 Paris
Woman drying herself c1890-95
Pastel on paper, 64.8 × 63.5 cm
Sir Alexander Maitland gift 1960, NGS
2226

2
Edgar Degas
Paris 1834 – 1917 Paris
Group of dancers
Paper on canvas, 46 × 61 cm
Sir Alexander Maitland gift 1960, NGS
2225

3
Edgar Degas
Paris 1834 – 1917 Paris
Diego Martelli 1879
Canvas, 110.5 × 100.5 cm
Purchased 1932, NGS 1785
 Martelli (1839-96) was a Florentine
writer and art critic who had been
associated in the 1860s with the Mac-
chiaioli, a group of artists based in
Tuscany with links with Paris. This
portrait of the sitter in his Paris apart-
ment was painted on Martelli's visit to
the city 1878-79. The work is notable
for its informality and its high view-
point. Degas developed his portrait
from a sequence of drawings and a
slightly earlier painting of the sitter
which is now in the National Art
Museum, Buenos Aires. Degas himself
was part-Italian in descent and studied
in Italy 1856-59.

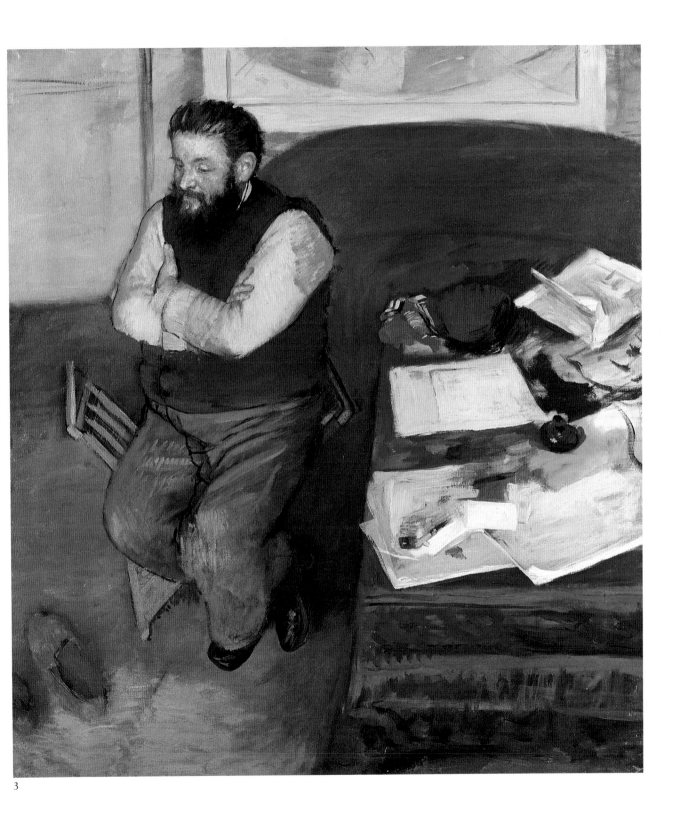

3

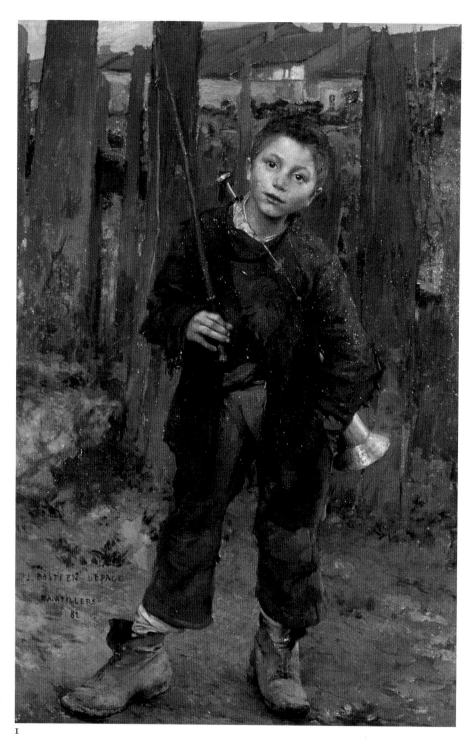

I

1
Julien Bastien-Lepage
Damvillers 1848 – 1884 Paris
'Pas Mèche' 1882
Canvas, 132.1 × 89.5 cm
Purchased 1913, NGS 1133

2
Alfred Sisley
Paris 1839/40 – 1899
Moret-sur-Loing
Molesey Weir, Hampton Court 1874
Canvas, 51.5 × 68.9 cm
Sir Alexander Maitland gift 1960, NGS
2235

3
Claude Monet
Paris 1840 – 1926 Giverny
Poplars on the Epte c1891
Canvas, 81.8 × 81.3 cm
Purchased 1925, NGS 1651

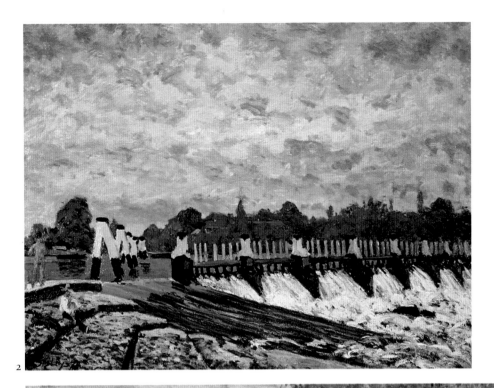

2

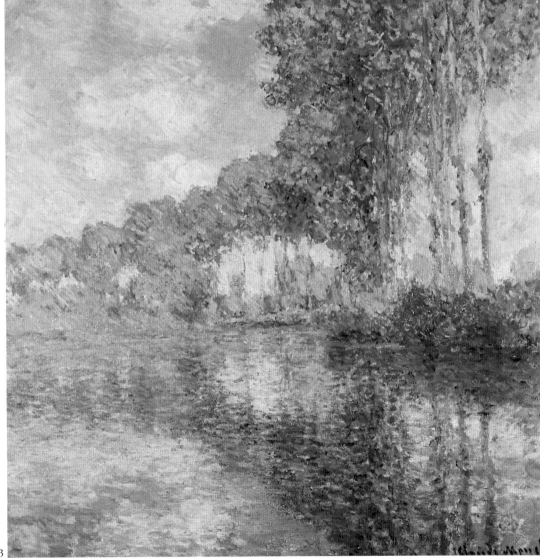

3

1
Paul Cézanne
Aix-en-Provence 1839 – 1906
Aix-en-Provence
Mt Ste-Victoire 1890-95
Canvas, 55 × 65.4 cm
Sir Alexander Maitland gift 1960, NGS
2236

2
Paul Cézanne
Aix-en-Provence 1839 – 1906
Aix-en-Provence
Big trees 1902-04
Canvas, 81 × 65 cm
Presented by deed of gift by Mrs A F
Kessler, received 1983, NGS 2206

3
Paul Gauguin
Paris 1848 – 1903 Marquesa Islands
The Vision after the Sermon 1888
Canvas, 72.2 × 91 cm
Purchased 1925, NGS 1643
 The story of Jacob wrestling with
the Angel, taken from Genesis 32,
22-31, is shown taking place in the
Breton countryside in the form of a
vision experienced by the local
peasants of Pont-Aven. In a letter to
Van Gogh, Gauguin explained that
'the landscape and the struggle exist
only in the imagination of these pray-
ing people, as a result of the sermon'.
The intense colours Gauguin used
heighten the emotional content, whilst
the two-dimensional representation of
space was inspired by Japanese wood-
cuts. Gauguin first visited Pont-Aven
in 1886 seeking 'wildness and primi-
tiveness', qualities he was later to find
in the South Seas.

4
Paul Gauguin
Paris 1848 – 1903 Marquesa Islands
Three Tahitians 1899
Canvas, 71.9 × 93 cm
Sir Alexander Maitland gift 1960,
NGS 2221

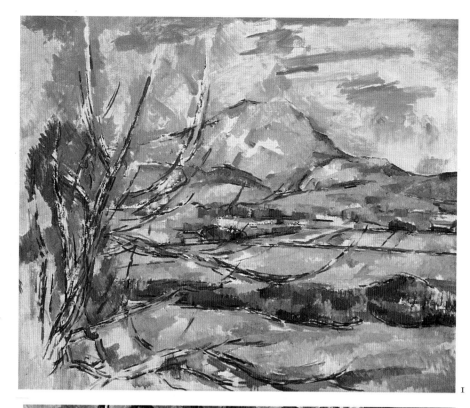

1

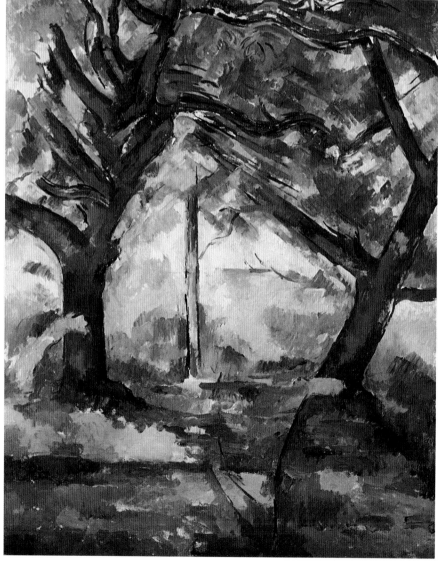

2

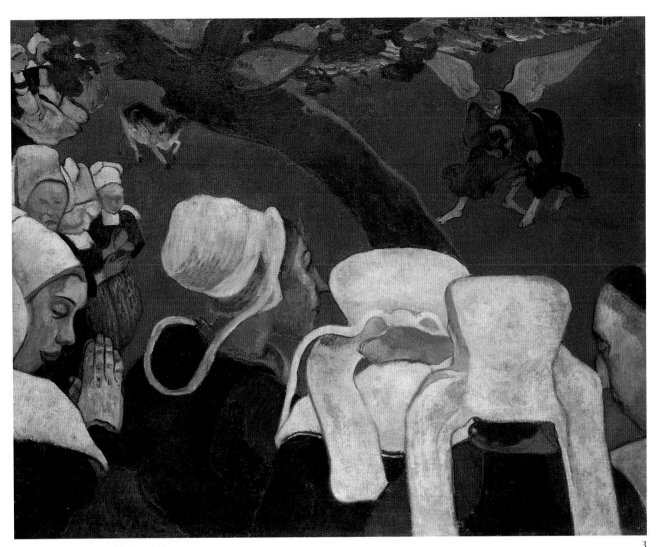

3

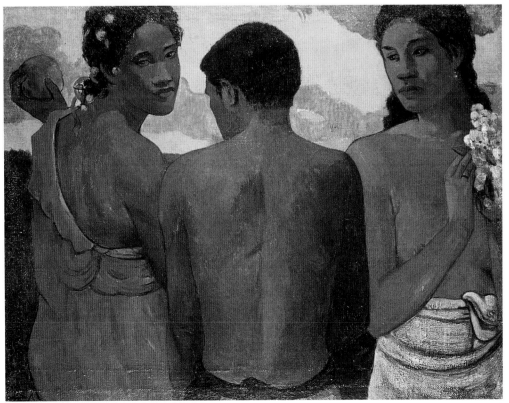

4

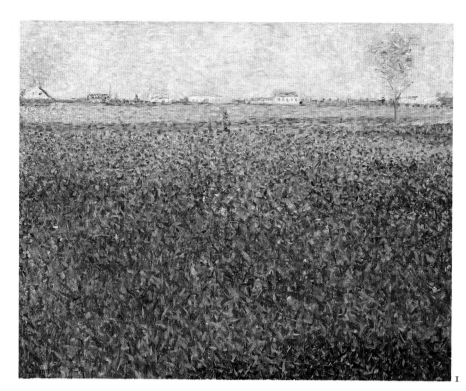

1
Georges Seurat
Paris 1859 – 1891 Paris
La Luzerne, St-Denis 1884-86
Canvas, 64 × 81 cm
Purchased with the aid of the NACF, a
Treasury Grant and the family of
Roger Fry 1973, NGS 2324

2
Paul Gauguin
Paris 1848 – 1903 Marquesa Islands
Martinique landscape 1887
Canvas, 115 × 88.5 cm
Sir Alexander Maitland gift 1960,
NGS 2220

Scottish School

Scottish painting developed a distinct identity only after the foundation of the Royal Scottish Academy in 1826, which slowed the migration south to London of native artists and ensured that those who remained had a supportive professional organization and an outlet through regular exhibitions. Allan Ramsay, being of an earlier generation, found it convenient to move his practice to London, where he became painter to the King, and the rival of Reynolds. The portrait of his second wife, the aristocratic Margaret Lindsay, with whom he eloped in 1751, has close affinities with the work of the French artists which he would have seen in Rome, with its delicate pastel colouring and feathery touch. It marks a move away from his earlier Scottish pictures and their simpler handling and strong and forthright presentation of character. Fortunately, however, the tradition of the earlier Ramsay portraits was continued and developed by Raeburn, whose *Macdonell of Glengarry*, with its dramatic side lighting, is one of the most effective evocations of the nineteenth-century romanticisation of the Highlands. The *Reverend Robert Walker*, on the other hand, is a puzzle picture. Uncharacteristic of the artist, both in scale and handling, it may not be by Raeburn at all.

The strengths of Scottish art in the nineteenth century were to be genre and landscape. Wilkie's precocious *Pitlessie Fair*, a portrait of his own Fife village, marks the commencement of the genre movement to which, in the *Letter of introduction*, painted only nine years later, he brought new skills

of subtle characterization and exquisite still-life painting. Jacob More and Alexander Nasmyth may be said to have been the fathers of the Scottish landscape school. *The Falls of Clyde* shows a noted eighteenth- and early nineteenth-century beauty spot, to which many tourists, including Coleridge and the Wordsworths, were to travel. Nasmyth's *Edinburgh Castle*, on the other hand, may have been painted more as a record or recollection of a part of Edinburgh which no longer existed, for by 1824 the Nor'loch had been drained, and the Royal Institution (Royal Scottish Academy) was being erected on the site. Dyce and Paton were both artists of the mid-century on whom the influence of the German revivalists, or Nazarenes, seems to have fallen. In only two years after painting *Francesca da Rimini*, Dyce moved to London, to work at the School of Design, but Paton spent his working life in Scotland. His extraordinary detailed style shows parallels to that of the Pre-Raphaelites, with some of whom he was friendly.

During the last three quarters of the nineteenth century Scottish landscape painting developed rapidly through the full-blown romanticism of McCulloch, whose *Inverlochy Castle* portrays a site described by Scott in *The Legend of Montrose*, to the anti-romanticism and square brushstrokes of the early Glasgow School painters. Guthrie's *Hind's daughter*, with its radiant blue-green brussels sprouts, and bullet-headed little girl, is a supreme example of the Glasgow square brush style.

1
Allan Ramsay
Edinburgh 1713 – 1784 Dover
David Hume (1711-76) 1776
Canvas, 76.2 × 63.5 cm
Mrs Macdonald Hume bequest 1858,
SNPG 1057

2
Allan Ramsay
Edinburgh 1713 – 1784 Dover
Anne Bayne, Mrs Allan Ramsay
(died 1743)
Canvas, 68.3 × 54.7 cm
Purchased 1983, SNPG 2603

3
Allan Ramsay
Edinburgh 1713 – 1784 Dover
Jean-Jacques Rousseau 1766
Canvas, 75 × 64.8 cm
Purchased 1890-1, NGS 820

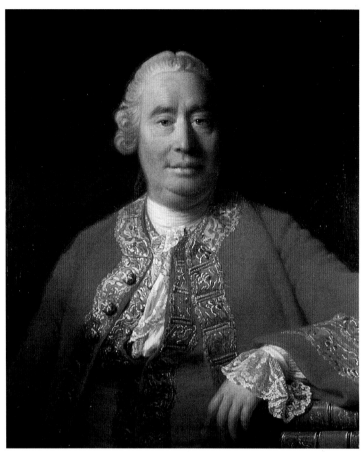

1

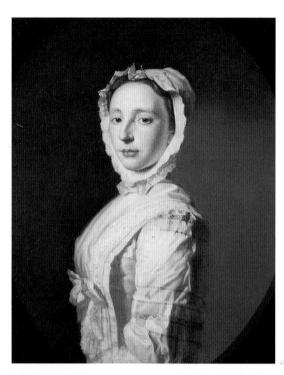

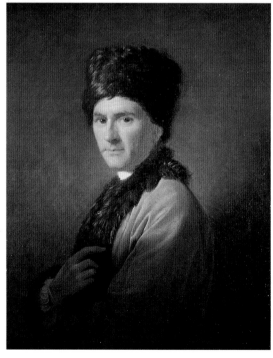

Allan Ramsay
Edinburgh 1713 – 1784 Dover
The painter's wife 1754-55
Canvas, 76.2 × 63.5 cm
Lady Murray of Henderland bequest
1861, NGS 430

Allan Ramsay spent three years, 1736-38, in Italy and started a studio in London in 1739, where he quickly became one of the leading portrait painters in the city. His first wife (of whom there is a painting in the Scottish National Portrait Gallery) died in 1743 and this picture depicts Margaret, his second wife. The daughter of Sir Alexander Lindsay of Evelick, she eloped with Ramsay in 1752. This portrait was painted in Italy where the couple lived *c*1755-57. Ramsay worked at the French Academy at Rome during his stay, and his style, which already had marked affinities with the work of the French, was affected by his visit.

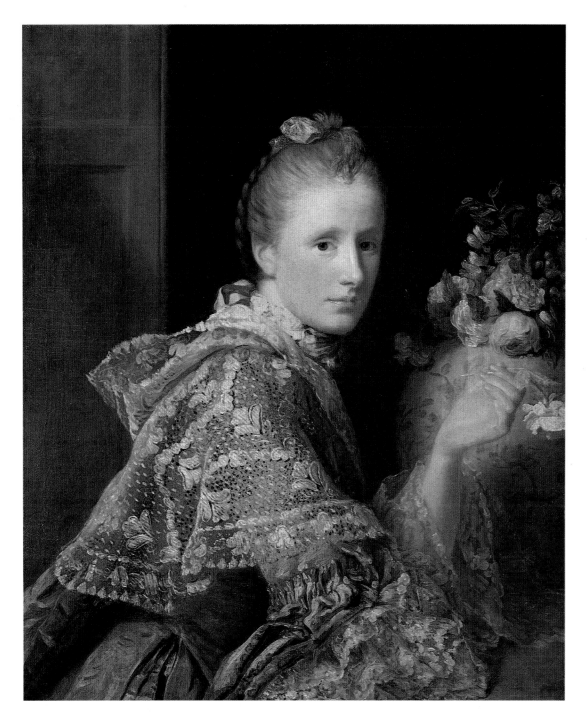

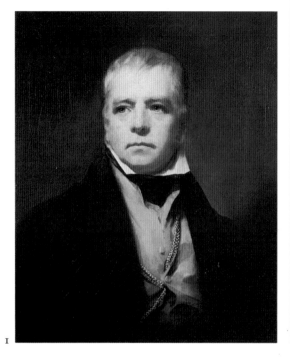

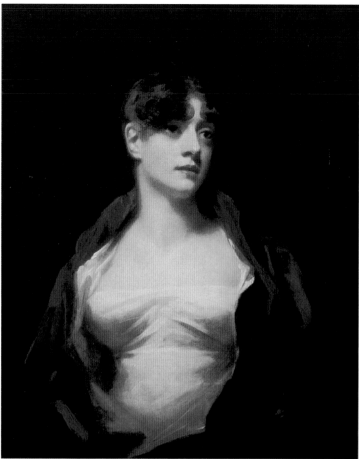

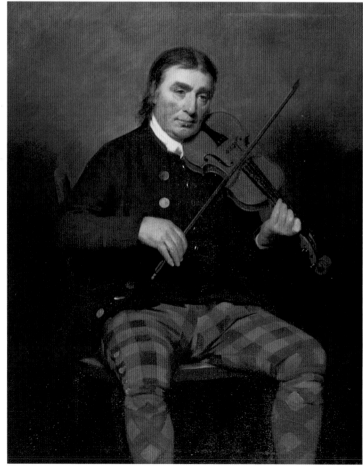

1

1
Sir Henry Raeburn
Stockbridge 1756 – 1823 Edinburgh
Sir Walter Scott (1771-1832) 1822
Canvas, 76.2 × 63.5 cm
Purchased 1935, SPNG 1286

2
Sir Henry Raeburn
Stockbridge 1756 – 1823 Edinburgh
Mrs Scott Moncrieff c1814
Canvas, 75 × 62.3 cm
Transferred from the Royal Scottish
Academy 1910, NGS 302

3
Sir Henry Raeburn
Stockbridge 1756 – 1823 Edinburgh
Neil Gow (1727-1807)
Canvas, 123.2 × 97.8 cm
Purchased 1886, SNPG 160

Sir Henry Raeburn
Stockbridge 1756 – 1823 Edinburgh
The Reverend Robert Walker skating on
Duddingston Loch 1784
Canvas, 76.2 × 63.5 cm
Purchased 1949, NGS 2112

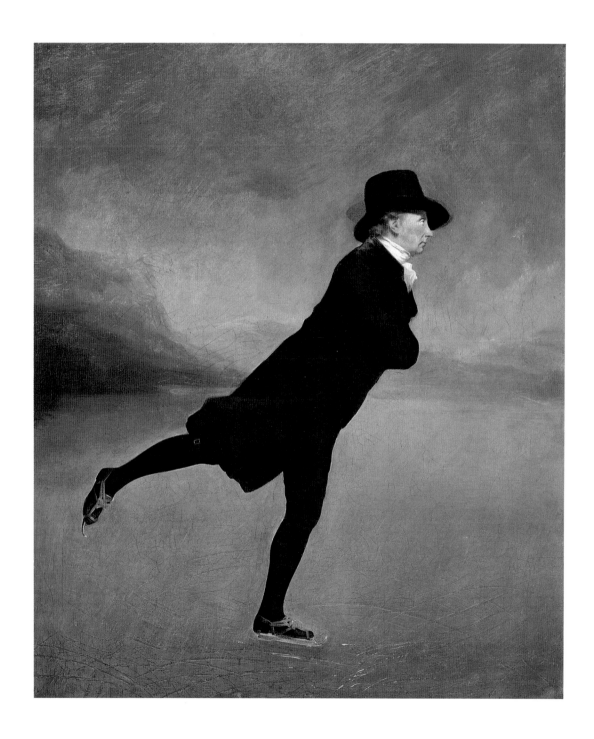

1
Sir Henry Raeburn
Stockbridge 1756 – 1823 Edinburgh
Colonel Alastair Macdonell of Glengarry
Canvas, 241 × 150 cm
Purchased 1917, NGS 420

2
David Allan
Alloa 1744 – 1796 Edinburgh
The Origin of Painting 1775
Panel, 38.1 × 30.5 cm
Mrs Byres gift 1874, NGS 612

3
Alexander Nasmyth
Edinburgh 1758 – 1840 Edinburgh
Robert Burns (1759-96) 1787
Canvas, 38.4 × 32.4 cm
Col William Burns bequest 1872,
SNPG 1063

4
Jacob More
Edinburgh 1740 – 1793 Rome
The Falls of Clyde
Canvas, 79.4 × 100.4 cm
Rt Hon J Ramsay MacDonald bequest
1938, NGS 1897

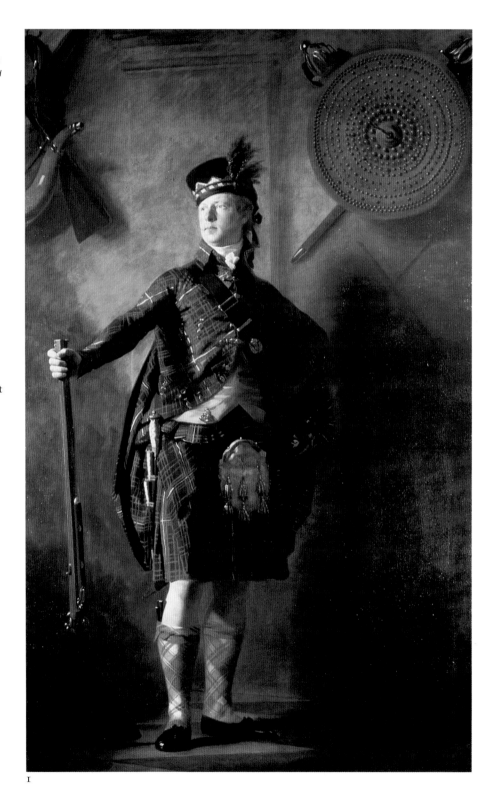

I

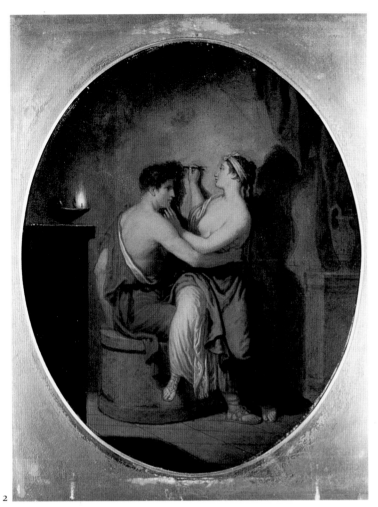

2

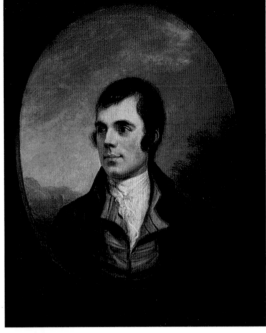

3

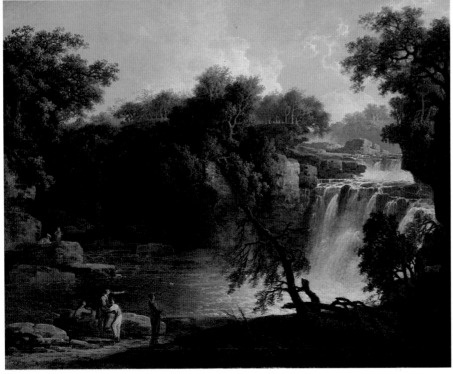

4

1
Andrew Geddes
Edinburgh 1783 – 1844 London
Sir David Wilkie (1785-1841) 1816
Panel, 66 × 48.2 cm
Kenneth Sanderson bequest 1944,
SNPG 1443

2
Alexander Nasmyth
Edinburgh 1758 – 1840 Edinburgh
Edinburgh Castle and the Nor' Loch
Canvas, 45 × 60.3 cm
Mrs E Pringle gift 1948, NGS 2104

3
Horatio McCulloch
Glasgow 1805 – 1867 Edinburgh
Inverlochy Castle 1857
Canvas, 90.2 × 157 cm
Royal Association for the Promotion of
Fine Arts gift 1897, NGS 288

1

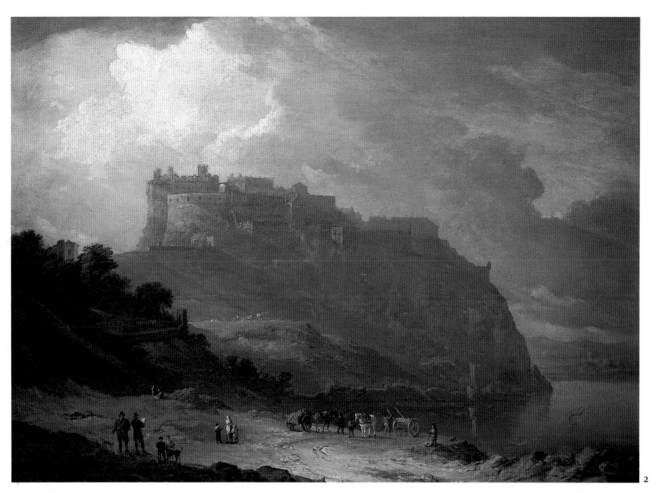

2

3

1
Sir David Wilkie
Cults, Fife 1785 – died 1841 at sea off
Malta
The letter of introduction 1813
Panel, 61 × 50.2 cm
Purchased 1938, NGS 1890

2
Sir David Wilkie
Cults, Fife 1785 – died 1841 at sea off
Malta
Pitlessie Fair 1804
Canvas, 58.5 × 106.7 cm
Purchased 1921, NGS 1527

1

3

Sir Joseph Noel Paton
Dunfermline 1821 – 1901 Edinburgh
The Quarrel of Oberon and Titania
Canvas, 99 × 152 cm
Purchased 1850, NGS 293

Sir Joseph Noel Paton was born in Dunfermline and studied at the Royal Academy schools in London where he made friends with John Everett Millais, the Pre-Raphaelite painter. Paton was appointed the Queen's Limner for Scotland in 1866. This painting illustrates an episode from William Shakespeare's play *A Midsummer Night's Dream* where the King and Queen of the Fairies argue over the custody of a 'changeling boy'. Paton made his first study for the composition in 1846 and also made preparatory figure drawings from clay models. The picture is one of the most detailed and highly worked of many Victorian paintings dealing with fairies. The artist was probably influenced by Henry Fuseli's Shakespearean works with their contrasting sizes of figures.

2

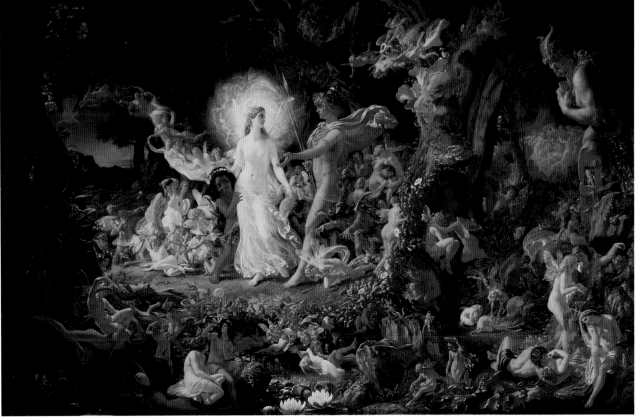

3

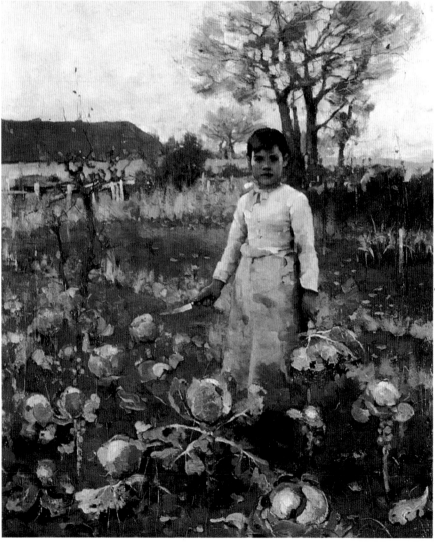

1
William Dyce
Aberdeen 1806 – 1864 Streatham
Francesca da Rimini
Canvas, 142 × 176 cm
Transferred from the Royal Scottish
Academy 1910, NGS 460

2
Sir James Guthrie
Greenock 1859 – 1930 Rhu
A Hind's daughter
Canvas, 91.5 × 76.2 cm
Sir James and Lady Caw bequest 1951,
NGS 2142

2

English and American Schools

The English School is not comprehensively represented in the National Gallery of Scotland by intention for it has always been believed in Edinburgh that the Scottish should predominate. Nevertheless, the English pictures in the collection, particularly in the Mound building, are often of remarkably fine quality. Numerically, however, there are more English pictures hung in the Portrait Gallery.

The Galleries' collections start with substantial groups by Lely, Wissing and Kneller. There is only one small but choice Hogarth, of *Sarah Malcolm* (1723/3), a picture painted on the day of this murderess's execution and one of the special treasures that belonged to Horace Walpole (1717-97), connoisseur and celebrated man of letters. Walpole commissioned from Sir Joshua Reynolds *The Ladies Waldegrave* (1780), which represents the painter at the height of his powers. This delightful composition of Walpole's three great-nieces used to hang at Strawberry Hill, Twickenham, Walpole's Thames-side Gothick villa. There are another eleven paintings by Reynolds divided evenly between the two buildings. Gainsborough can be very well studied in Edinburgh in three great full-lengths, the most famous being *The Hon Mrs Graham* (1775-76), but also the *Duke of Argyll* (1770s) and *Mrs Hamilton Nisbet* (1777) are of magnificent quality. Then there is the early Suffolk period *Landscape with a view of Cornard village*, and the mature, rhapsodic *Rocky landscape* (c1783). Other fashionable portrait painters, such as Beechey, Hoppner, Lawrence, Northcote, Opie and Romney, abound.

Landscape is more patchily represented. There are two Constables, one the majestic *Vale of Dedham* (1828), the other a small oil-sketch, *On the Stour*. J M W Turner, usually thought of as Britain's greatest landscape painter, is represented by *Somer Hill, Tonbridge* (1811), a soft brown somnolent view of a Kent country house. The National Galleries also have a fine and diverse collection of Turner's watercolours. Two Cotmans and three Cromes represent the twin peaks of the Norwich School. While Cotman is concerned with pattern making, Crome re-interprets Dutch seventeenth-century art in a very distinctive style.

Of Scottish topographical interest, and on a noble scale, are the pair by James Ward of the *Eildon Hills and the Tweed* and *Melrose Abbey, with the pavilion in the distance*. His brother-in-law George Morland is represented by four good examples, the two most carefully resolved being *Comforts of Industry* and *Miseries of Idleness*, both engraved in 1790. As a contrast in mood are three delightful small Boningtons. In 1829-31 the Royal Scottish Academy variously commissioned or bought five large canvases by William Etty that were transferred to the National Gallery. From later in the nineteenth century, the Pre-Raphaelites are poorly represented, as are many aspects of English Victorian narrative painting, but this is in marked contrast to the Scottish holdings. There are, however, a dramatic Landseer, *Rent-day in the Wilderness*, a saccharine J E Millais entitled *Sweetest eyes were ever seen*, D G Rossetti's *Beata Beatrix*, a group of three works by G F Watts and an exquisite small oil by Albert Moore, *Beads*.

American paintings have never deliberately been collected, but the Galleries have recently bought a vast canvas by Benjamin West of *Alexander III, King of Scotland, saved from the fury of a stag by Colin Fitzgerald* (1786). In the collection are also a fine portrait of the *Twelfth Earl of Eglington* by J S Copley and four portraits by Mather Brown. From the nineteenth century are Thomas Doughty's *View of the flat rock on the Scuylkill, near Philadelphia*, and Frederic Church's impressive view of *Niagara Falls* (1867). J J Whistler is represented by a portrait of J J Cowan,while there are five pictures by Sargent, the most memorable and glamorous being of *Lady Agnew of Lochnaw*.

1
Hans Eworth
born Antwerp, active in England
1549 – c1574
Henry Stewart, Lord Darnley
(1545-1567), 1555
Panel, 74 × 55.2 cm
Purchased 1980, SNPG 2471

2
William Dobson
London 1610 – 1646 (?)
Charles II (1630-85)
Canvas, 153.6 × 129.8 cm
Purchased 1935, SNPG 1244

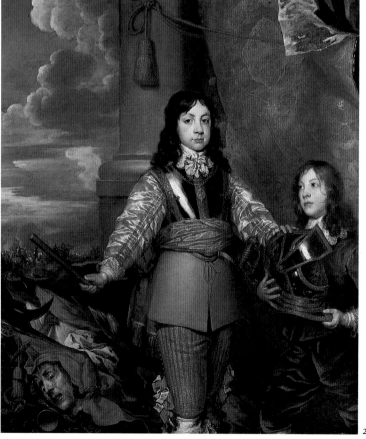

Sir Peter Lely
Soest 1618 – 1680 London
John Maitland, Duke of Lauderdale
(1616-82)
Canvas, 124.4 × 101.6 cm
Purchased 1967, SNPG 2128

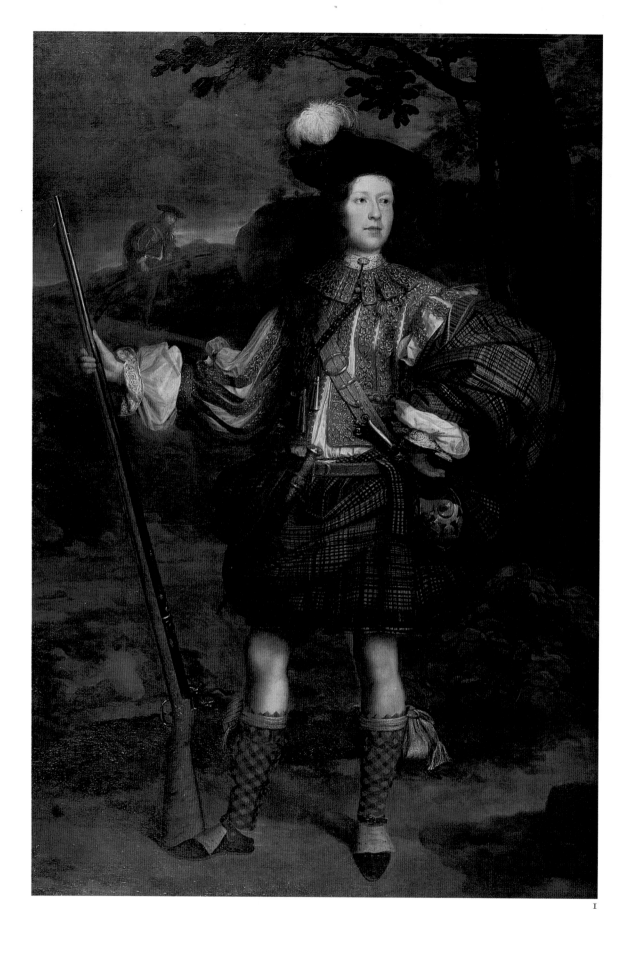

I

1

John Michael Wright
London 1617 – 1694 London
Mungo Murray
Canvas, 224.8 × 154.3 cm
Purchased 1925, SNPG 997

Lord Mungo is dressed for hunting, wearing the belted plaid, a double width of tartan cloth about five yards long, unsewn and belted round the body to form a kilt below the waist and a mantle above. He also wears a fashionable doublet, holds a flintlock sporting gun and carries two scroll-butt pistols in his belt. In addition he bears a dirk and a ribbon-basket sword. His servant in the background carries a long bow, traditionally used for hunting deer.

2

Richard Wilson
Penegoes 1714 – 1782 Colommendy
Flora Macdonald (1722-90) 1747
Canvas, 76.4 × 53.7 cm
Purchased 1931, SNPG 1162

3

Sir Joshua Reynolds
Plympton 1723 – 1792 London
The Ladies Waldegrave 1780
Canvas, 143.5 × 168 cm
Purchased with the aid of the NACF
1952, NGS 2171

2

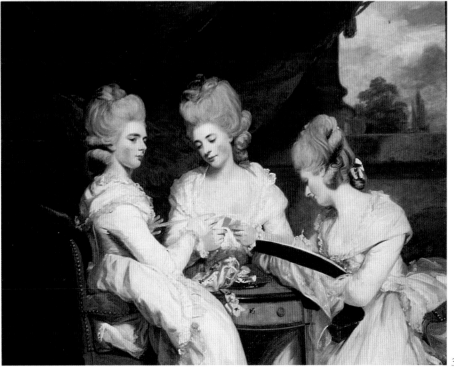

3

1
Thomas Gainsborough
Sudbury 1727 – 1788 London
John Campbell, 4th Duke of Argyll
(c1693-1770)
Canvas, 235 × 154.3 cm
Purchased 1953, SNPG 1596

2
Thomas Gainsborough
Sudbury 1727 – 1788 London
The Hon Mrs Graham 1775-77
Canvas, 237 × 154 cm
Robert Graham of Redgorton bequest
1859, NGS 332

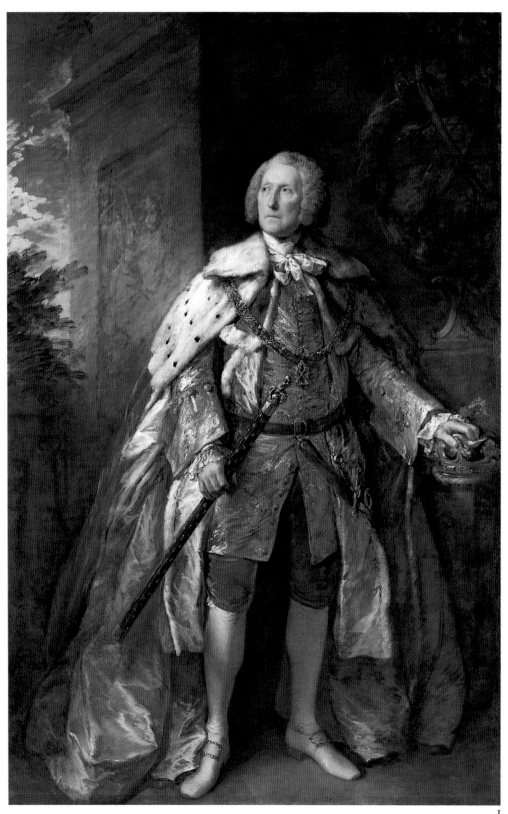

Thomas Gainsborough
Sudbury 1727 – 1788 London

1

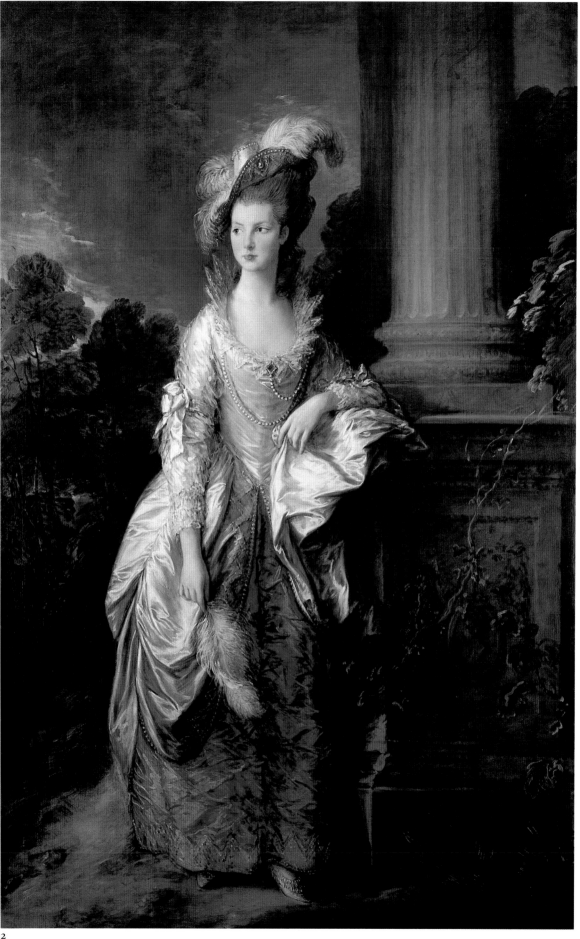

1
Thomas Gainsborough
Sudbury 1727 – 1788 London
Landscape with a distant view of Cornard village c1747
Canvas, 76.2 × 151 cm
Purchased 1953, NGS 2174

2
Thomas Gainsborough
Sudbury 1727 – 1788 London
Rocky landscape c1783
Canvas, 119.4 × 147.3 cm
Purchased 1962, NGS 2253

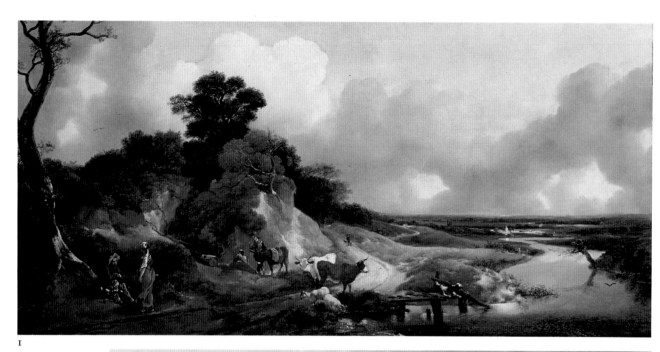

1

2

4

3

This work was commissioned by
Francis Humberston MacKenzie (later
Baron MacKenzie of Kintail and Lord
Seaforth) to illustrate a legendary
exploit of his ancestor in the thirteenth
century. Colin Fitzgerald, a refugee
from Ireland, was said to have saved
the King's life by shooting an enraged
stag in the forehead. He was granted
the lands of Kintail as a reward, found-
ing the Clan MacKenzie. While there is
no historical basis for the story, the
painting is symptomatic of the new
interest in Scots history, real or
imaginary, at the end of the eighteenth
century. West, an American painter
who studied in Italy 1760-63, brought
his Roman training to bear upon this
subject, combining medieval myth
with classical history piece.

1
John Crome
Norwich 1768 – 1821 Norwich
The Beaters 1810
Panel, 54.6 × 86.4 cm
Purchased 1970, NGS 2309

2
Joseph Mallord William Turner
London 1775 – 1851 London
Somer Hill, Tonbridge first exhibited
1811
Canvas, 91.5 × 122.3 cm
Purchased 1922, NGS 1614

1

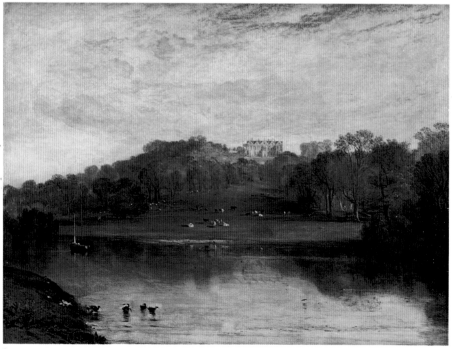

2

John Constable
East Bergholt 1776 – 1837 London
Dedham Vale 1828
Canvas, 145 × 122 cm
Purchased 1944, NGS 2016

John Constable was born in Suffolk and dedicated most of his life to painting part of the Stour valley on the borders of Essex and Suffolk, concentrating upon the formation of clouds and natural effects of light and weather. This painting shows a view of the Stour from Langham Coombe, looking towards the village of Dedham. The topographical accuracy of the painting was provided by various studies made by Constable in 1802 and c1805, and relies particularly upon an oil-sketch of 1802 in the Victoria and Albert Museum, London. The painting probably paid homage to the artist and patron Sir George Beaumont, who died in 1827 and whose collection formed part of the original group of paintings in the National Gallery, London. Inspired by Beaumont's small *Hagar and the Angel* by Claude, this composition is a mature summation of Constable's paintings of his native countryside.

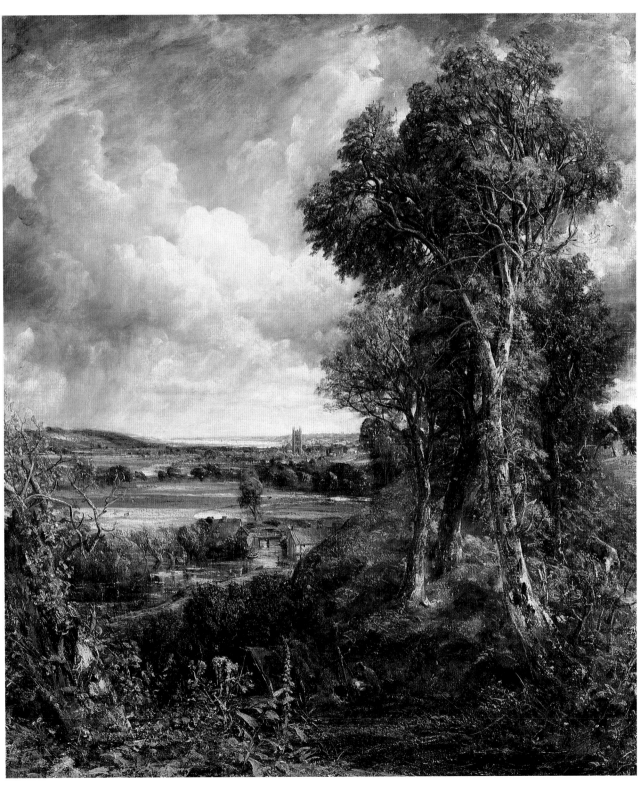

1
Richard Parkes Bonington
Arnold 1802 – 1828 London
Landscape with mountains 1826
Millboard, 25.1 × 33 cm
Purchased 1910, NGS 1017

2
Sir Thomas Lawrence
Bristol 1769 – 1830 London
Lady Robert Manners (1737-1829)
Canvas, 138.5 × 110.5 cm
Mrs Nisbet Hamilton Ogilvy of Biel
bequest 1921, NGS 1522

3
Sir Edwin Landseer
London 1802 – 1873 London
Rent-day in the wilderness 1868
Canvas, 122 × 265 cm
Sir Roderick Murchison bequest 1871,
NGS 586

4
George Romney
Dalton-le-Furness 1734 – 1802
Kendal
Jane, Duchess of Gordon (1749-1812)
and her son George, Marquess of Huntly
(1770-1836)
Canvas, 126.4 × 102.5 cm
Purchased 1972, SNPG 2208

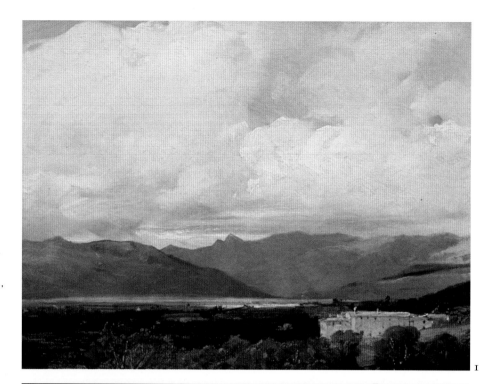

1

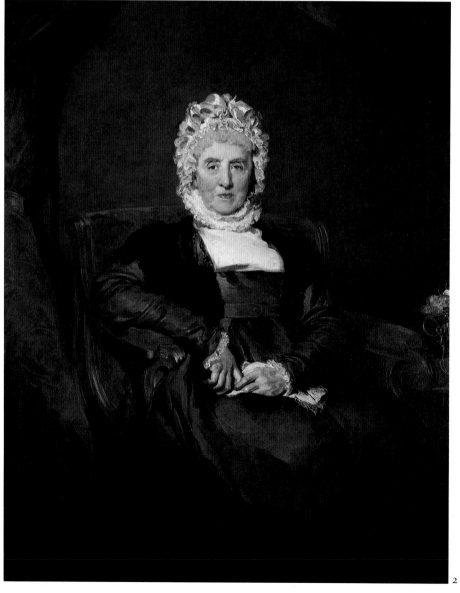

2

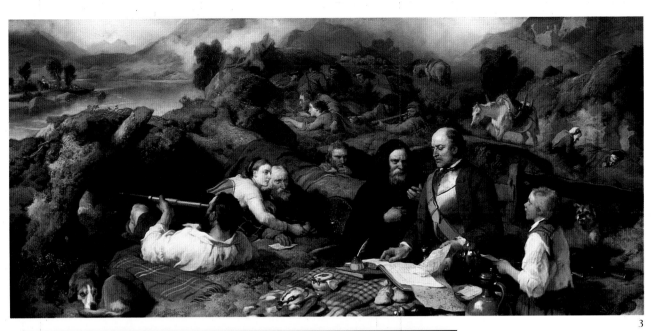

3

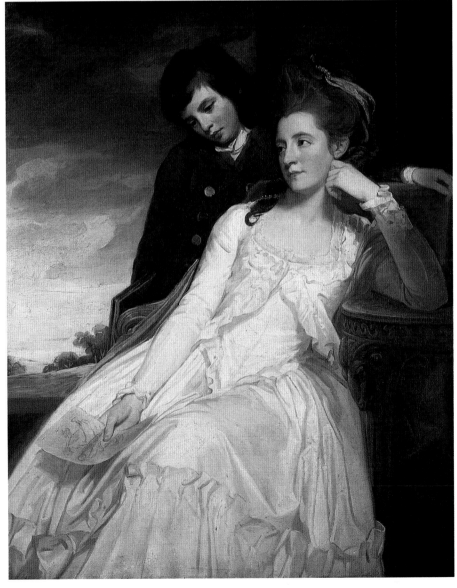

4

1
Frederic Edwin Church
Hartford 1826 – 1900 New York
Niagara Falls, from the American side
Canvas, 260 × 231 cm
John S Kennedy gift 1887, NGS 799

2
John Singer Sargent
Florence 1856 – 1925 London
Lady Agnew of Lochnaw
Canvas, 124.5 × 99.7 cm
Purchased 1925, NGS 1656

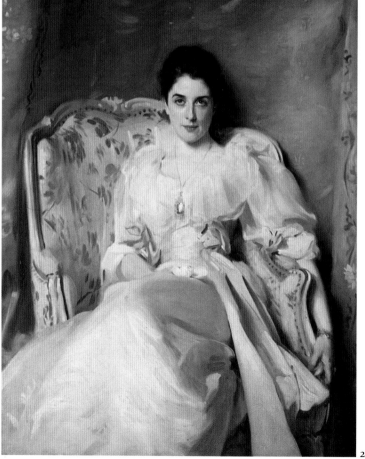

German and Danish Schools

The Galleries' holding of these schools is small in number. From the sixteenth century, Hans Holbein's *Allegory* illustrates one of the most important themes in Reformation iconography, the contrast of the Law of the Old Testament and the Grace of the New. Pictures of this subject were also produced by Holbein's contemporary Lucas Cranach who painted the entirely secular *Venus and Cupid* in the late 1530s.

One of the most inventive, albeit on a small scale, of painters was the Frankfurt master Adam Elsheimer who had travelled, via Venice, to Rome by 1600. His intricate compositions painted on copper inspired others, most particularly Rubens who made many drawings after Elsheimer's work, including one after his *Stoning of St Stephen*. The Galleries are fortunate to possess another masterpiece by Elsheimer, *Il Contento*, illustrating an episode from a Spanish picaresque novel in which Jupiter sends Mercury to earth to abduct the god Content whom the people were worshipping.

An interesting link with Scotland is provided from the Romantic era by Tischbein's full-length portrait of the poetess and novelist Lady Charlotte Campbell (1775-1861).

Recently, much attention has been given to the Biedermeier period in European painting (1815-48), so called after the fictional Gottlieb Biedermaier whose character satirized the pretensions of the German and Austrian bourgeoisie. Danish paintings of this era also conform to the precepts of Biedermeier and an interesting example is the group portrait of the family of the jeweller Johan Winther, shown in the rooms above their shop in Copenhagen in 1827.

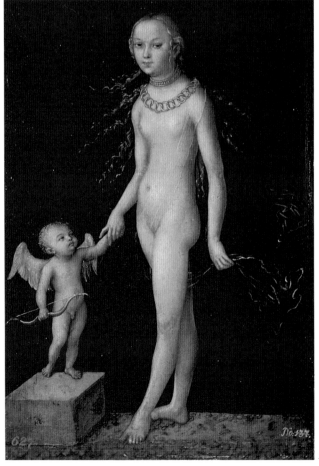

1

Hans Holbein the Younger
Augsburg 1497/8 – 1543 London
Allegory of the Old and New Testaments
Panel, 50 × 60.5 cm
Purchased with the aid of the NHMF
and National Heritage Purchase Grant
(Scotland) 1981, NGS 2407

The son of a distinguished painter,
Holbein was born in Augsburg and
settled in Basle. He visited England in
1526 and returned in 1532. He
painted altarpieces and murals but is
best known for his portraits of mem-
bers of the court of Henry VIII, whose
service he entered about 1535. This
panel is effectively a visual sermon of
Lutheran doctrine. It illustrates a cen-
tral theme of the Reformation contras-
ting Law (Lex) with Grace (Gratia), the
old and new dispensations, which are
represented allegorically on the left
and right of the picture. The subject
was often painted, and derives primar-
ily from portrayals of the theme by
Lucas Cranach the Elder.

2

Lucas Cranach the Elder
Kronach 1472 – 1553 Weimar
Venus and Cupid before 1537
Panel, 38.1 × 27 cm
Eleventh Marquess of Lothian bequest
1941, NGS 1942

3

Adam Elsheimer
Frankfurt 1578 – 1610 Rome
'Il Contento'
Copper, 30 × 42 cm
Received in lieu of tax 1970, NGS 2312

4

Adam Elsheimer
Frankfurt 1578 – 1610 Rome
The Stoning of St Stephen c1602-05
Copper, 34.7 × 28.6 cm
Purchased 1965, NGS 2281

3

4

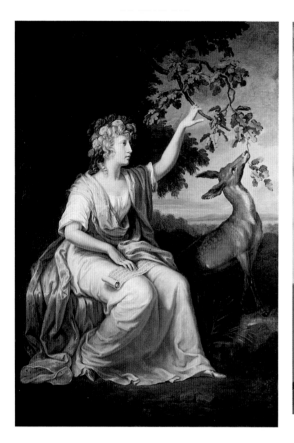

Johann Wilhelm Tischbein
Haina 1751 – 1829 Eutin
Lady Charlotte Campbell (1775-1861)
Canvas, 197.2 × 134 cm
Purchased 1975, SNPG 2275

Emilius Ditlev Baerentzen
Copenhagen 1799 – 1868
Copenhagen
The Winther family 1827
Canvas, 70.5 × 65.5 cm
Purchased 1988, NGS 2451

Twentieth Century

Scotland's collection of twentieth century art, both Scottish and international, is housed in a separate Gallery of Modern Art. This Gallery was founded only in 1959 and did not inherit a large body of works from the National Gallery. Consequently the Trustees decided in the early years to allocate a larger proportion of its acquisition funds to the Gallery to enable it to catch up, with the result that significant examples of many of the great twentieth century movements were acquired. In its first ten years important paintings and sculptures by English, Scottish and foreign artists were purchased, among them, Sickert, Matthew Smith, Epstein, Duncan Grant, Wyndham Lewis, Bomberg, Paul Nash, Moore, Ben Nicholson, Hepworth, Hitchens, Piper, Sutherland, Pasmore, Butler, Hilton; Fergusson, Peploe, Cadell, Hunter, MacTaggart, Colquhoun, MacBryde, Eardley, Gear, Davie; and Gontcharova, Larionov, Jawlensky, Nolde, Kirchner, Picasso, Léger, Lipchitz, Sironi, Morandi, de Stäel, Dubuffet and Appel.

The Gallery now has a major collection of twentieth-century Scottish art. Its other greatest strengths are its holdings of German Expressionism, Surrealism and French art generally. The last twenty years have seen a number of important acquisitions in these areas, for example, Dix's *Nude girl on a fur* (1932), Feininger's *Gelmeroda III* (1913) and Barlach's carved wooden figure *The terrible year, 1937* (1936); Giacometti's surrealist masterpiece, *Woman with her throat cut* (1932), Miró's *Composition* (1925) and Magritte's *Black flag* (1937); and fine Cubist paintings by Braque (*Candlestick*, 1911) and Picasso (*Guitar, gas-jet and bottle*, 1912-13), as well as an outstanding group of late works by Léger, including the first of his large oil-studies for *The constructors*. Contemporary British painting is also well represented, with works by Freud, Kossoff, Auerbach, Kitaj, Walker, Lebrun, Bellany, Campbell, Wiszniewski, Currie and Howson.

To complement its holdings of paintings and sculpture, the Gallery has an extensive collection of prints and drawings, now numbering nearly three thousand items, and a growing archive devoted to material on twentieth-century Scottish art.

1
Pierre Bonnard
Fontenay-aux-Roses 1867 – 1947
Le Cannet
*Lane at Vernonnet c*1912-14
Canvas, 74 × 62.9 cm
Purchased with funds given by Mrs
Charles Montagu Douglas Scott, 1961,
SNGMA 2932

2
Edouard Vuillard
Cuiseaux 1868 – 1940 La Baule
*Candlestick c*1900
Canvas, 41 × 73 cm
Mrs Isabel Traill gift 1979,
SNGMA 2935

Henri Matisse
Le Cateau-Cambrésis 1869 – 1954
Nice
The painting lesson 1919
Canvas, 74 × 93 cm
Sir Alexander Maitland bequest 1965.
SNGMA 929

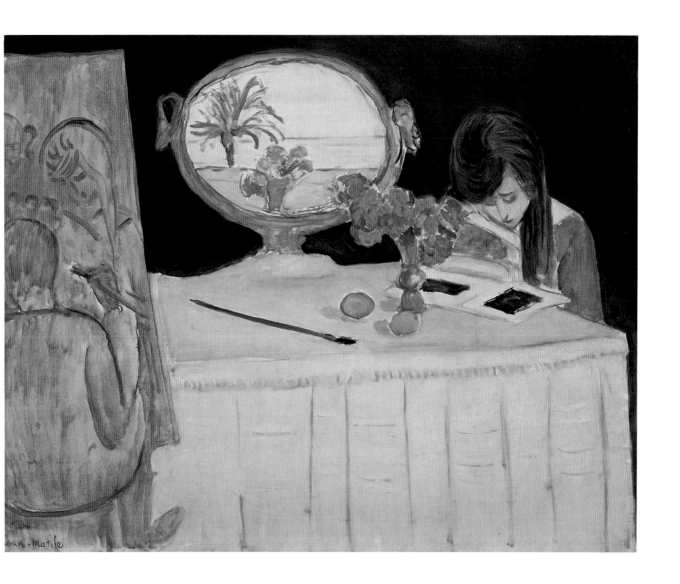

André Derain
Chatou 1880 – 1954 Paris
Collioure 1905
Canvas, 60.7 × 73.5 cm
Purchased 1973, SNGMA 1280

This is a vibrant example of Derain's early Fauve style. Derain, Matisse and a number of other artists were dubbed by one critic *les fauves* (wild animals), when they showed their brightly coloured and strongly expressive paintings at the 1905 Salon d'Automne in Paris. But, as *Collioure* shows, these works were also very decorative. The landscape is conceived not in traditional terms using linear and atmospheric perspective, but as a carefully constructed pattern of colours and shapes.

Georges Braque
Argenteuil-sur-Seine 1882 – 1963
Paris
Candlestick 1911
Canvas, 46 × 38 cm
Purchased 1976, SNGMA 1561

Braque's picture was painted at a time when Braque and Picasso had developed Cubism to its most complex and evocative stage, dubbed 'analytical' because objects are fragmented, distorted and put together again. There is no longer a single viewpoint in the painting. On the contrary, everything has been treated in a unified way so that lines and transparent, overlapping planes are distributed throughout the picture and all sense of illusionistic space is denied. *Le Bougeoir* shows a still life on a bedside table. The title indicates a portable candlestick with saucer and handle, but only the candle itself is distinguishable at the top of the picture. Other recognizable objects are a pipe, scissors and a five *centimes* newspaper *L'Indépendant*.

1
Pablo Picasso
Malaga 1881 – 1973 Antibes
Guitar, gas-jet and bottle 1912-13
Canvas, 70.4 × 55.3 cm
Purchased 1982, SNGMA 2501

2
Fernand Léger
Argentan 1881 – 1955 Gif-sur-Yvette
Woman and still life 1921
Canvas, 65.5 × 92 cm
Purchased 1966, SNGMA 962

3
Pablo Picasso
Malaga 1881 – 1973 Antibes
Soles 1940
Canvas, 60 × 92 cm
Purchased 1967, SNGMA 1070

I

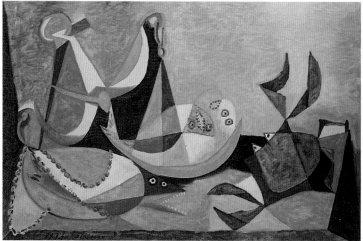

3

Fernand Léger
Argentan 1881 – 1955 Gif-sur-Yvette
The constructors: the team at rest 1950
Canvas, 162 × 129.5 cm
Purchased 1984, SNGMA 2845

This is one of the earliest in a series of major oil-paintings that Léger made in 1950-51 of construction workers putting up the metal skeleton of a building. The subject became almost a symbol of post-war European reconstruction and of Léger's belief in social progress, and in a tough figurative art to promote it. Léger was fascinated by the contrast between the forms of the construction workers, the geometrical architecture and the irregularly shaped clouds above. He later showed the series of paintings at the Renault factory outside Paris and was delighted by the response of the workers to the brilliant colours in his work and by their comments on the unreal drawing of the constructors' hands. Léger used things new and strange in order to make people more aware of the newness of a world that they were helping to create.

1

1
Walter Sickert
Munich 1860 – 1942 Bath
High-steppers c1938
Canvas, 132 × 122.5 cm
Purchased 1979, SNGMA 2099

2
F C B Cadell
Edinburgh 1883 – 1937 Edinburgh
Lady in black (Miss Don-Wauchope)
*c*1921
Canvas, 74.9 × 62.2 cm
G D Robinson bequest through the
NACF 1988, SNGMA 3350

3
Oskar Kokoschka
Pöchlarn 1886 – 1980 Montreux
Douglas Douglas Hamilton, 14th Duke of
Hamilton (1903-73) and Elizabeth,
Duchess of Hamilton (born 1916) 1969
Canvas, 89.8 × 129.8 cm
Purchased 1987, SNPG 2723

4
Oskar Kokoschka
Pöchlarn 1886 – 1980 Montreux
Summer II 1938-40
Canvas, 68.3 × 82.9 cm
Gift of the Government of
Czechoslovakia in exile 1942,
SNGMA 21

2

3

4

1
Otto Dix
Unterhaus 1891 – 1969
Hemmenhofen
Nude girl on a fur 1932
Canvas, 98.5 × 142.8 cm
Purchased 1980, SNGMA 2195

2
Ferdinand Hodler
Bern 1853 – 1918 Geneva
Lake Thun and the Stockhorn Mountains
1910
Canvas, 83 × 105.4 cm
Purchased 1975, SNGMA 1523

1

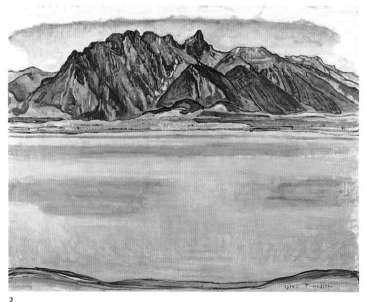

2

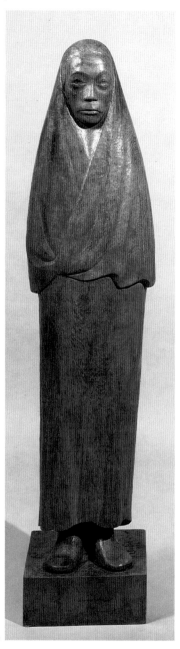

3

3
Ernst Barlach
Wedel 1870 – 1938 Rostock
The terrible year 1937, 1936
Oak, 142 × 31 × 28.5 cm
Purchased with the aid of the NACF,
the Patrons of the NGS and private
donations 1987, SNGMA 3036

Ernst Ludwig Kirchner
Aschaffenburg 1880 – 1938 Davos
*Japanese theatre c*1909
verso: *Interior with two figures c*1924
Canvas, 115 × 114.3 cm
Purchased 1965, SNGMA 911

This is one of many works with exotic subject matter that Kirchner painted in Dresden. Like his fellow members of the young, dynamic group *Die Brücke* (The Bridge) Kirchner wanted to make a decisive break with what he saw as the inhibiting traditions of the nineteenth century. Old Europe needed to be revivified by infusion from the vitality of other cultures, whether from the sculptures of the South Sea Islanders or the No plays of Japan. Above all the artist had to express himself directly and strongly, avoiding quiet harmonies and choosing instead invigorating contrasts. Thus in *Japanese Theatre* the forms are boldy outlined, colours are applied in flat, unmodulated areas and everything is geared towards maximum expression.

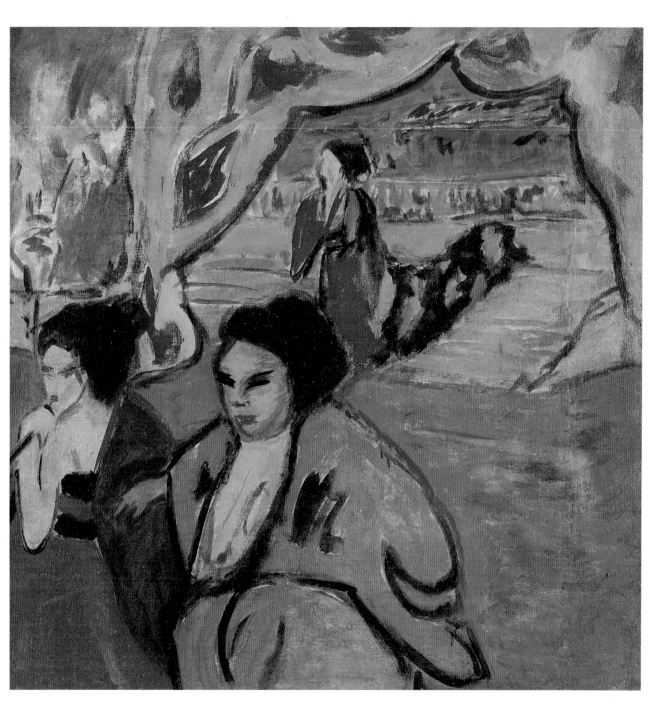

Paul Klee
Bern 1879 – 1940 Muralto
Threatening snowstorm 1927
Gouache and ink on paper,
48.9 × 31.4 cm
Miss Anna Blair bequest 1952,
SNGMA 1015

2
René Magritte
Lessines 1898 – 1967 Brussels
Black flag 1937
Canvas, 51.4 × 71.8 cm
Purchased 1972, SNGMA 1261

3
Ben Nicholson
Denham 1894 – 1982 London
Painting 1937
Board, 50.6 × 63.5 cm
Purchased 1979, SNGMA 2100

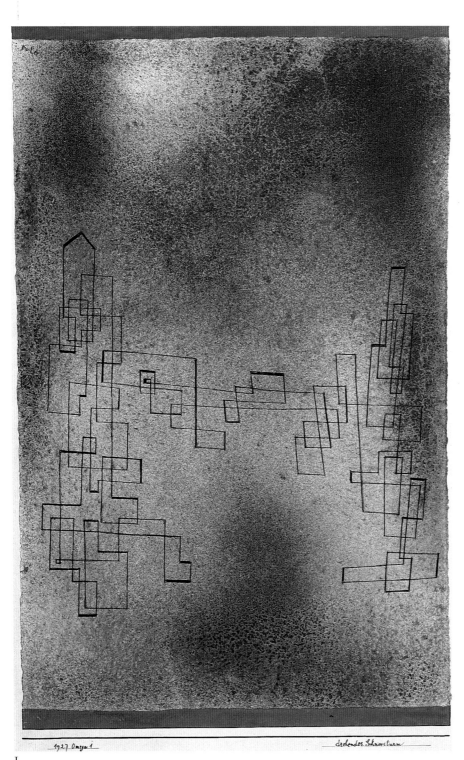

1927 Omega 1 drohender Schneesturm

1

2

3

1
Jacob Epstein
New York 1880 – 1959 London
Consummatum Est 1936-7
Alabaster, 61 × 223.5 × 81 cm
Purchased 1981, SNGMA 2304

2
Paul Nash
London 1889 – 1946 Boscombe
Landscape of the brown fungus 1943
Canvas, 56.5 × 38.7 cm
H J Paterson bequest 1988,
SNGMA 3425

3
Henry Moore
Castleford 1898 – 1986
Much Hadham
Reclining figure 1951
Bronze, 106 × 228.6 × 73.7 cm
Gift of the Arts Council of Great Britain
through the Scottish Arts Council
1969, SNGMA 1098

1

2

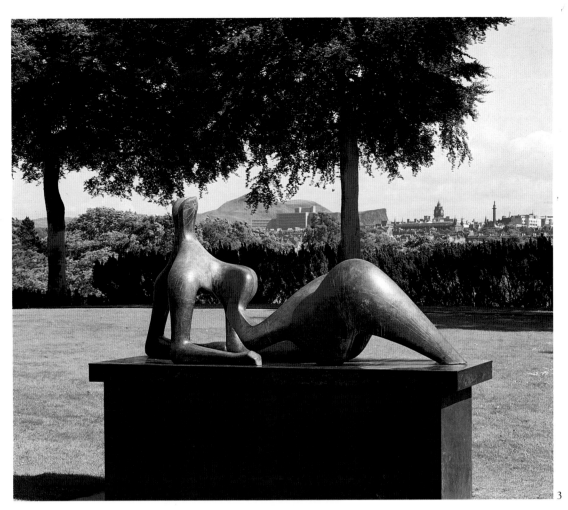

3

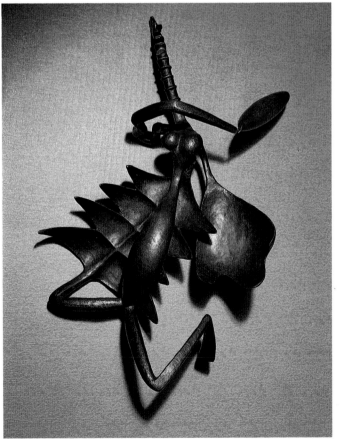

4

4

Alberto Giacometti
Borgonovo 1901 – 1966 Chur
Woman with her throat cut 1932
Bronze, 20.3 × 87.5 × 63.5 cm
Purchased 1970, SNGMA 1109

 Femme egorgée (Woman with her
throat cut) is the most complex and
macabre of Giacometti's surrealist
sculptures. It can be seen as an essay
on metamorphosis in art, as Gia-
cometti has mingled elements from the
human, animal (insect and crusta-
cean) and perhaps vegetable world. On
another level it displays an ambivalent
attitude towards sexual violence,
ecstasy and pain. The windpipe shape
with the cut in it is anatomically fairly
realistic: there is a torso with arched
stomach and small breasts; the legs are
splayed far apart, one ending in a
jagged backbone. The hand of one arm
has become a large scoop in which the
phallic pod of the other arm may rest.
Although the nominal subject of
Femme egorgée would appear to be
murder, an alternative reading of
sexual ecstasy is permitted by the
ambiguous mixture of sensual forms
in its implied violence.

1
Stanley Spencer
Cookham 1891 – 1959 Cliveden
Christ delivered to the People 1950
Canvas, 69 × 149 cm
Purchased 1983, SNGMA 2759

2
Jean Dubuffet
Le Havre 1901 – 1985 Paris
Villa by the road 1957
Canvas, 81.3 × 100.3 cm
Purchased 1963, SNGMA 830

3
Lucian Freud
born 1920 Berlin
Two men 1987-88
Canvas, 122 × 91.5 cm
Purchased 1988, SNGMA 3410

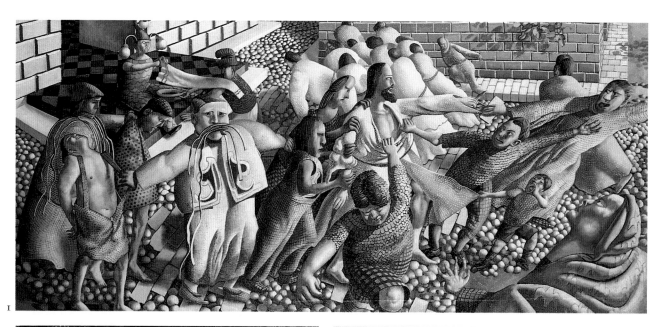

1

2

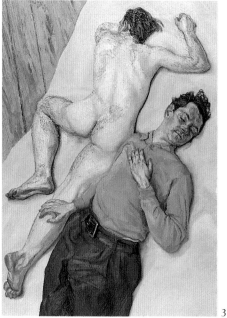

3

4
David Hockney
born 1937 Bradford
Rocky Mountains and tired Indians 1965
Canvas, 170.4 × 252.8 cm
Purchased 1976, SNGMA 1538

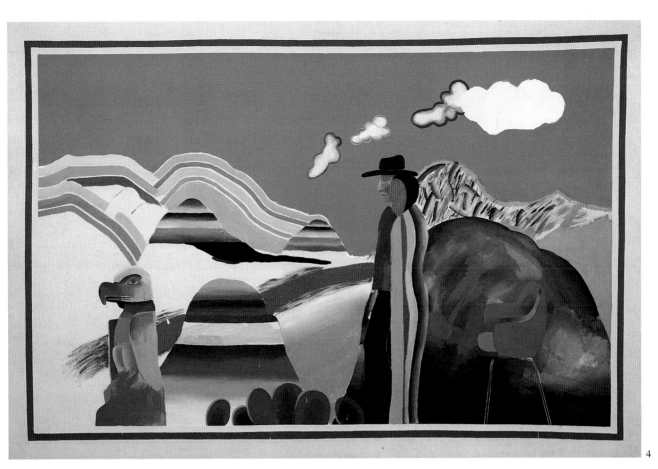

4

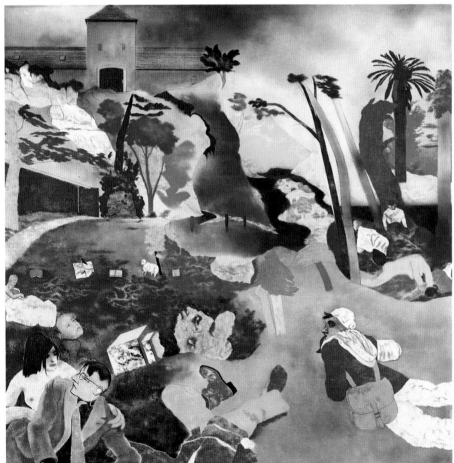

5

5
R B Kitaj
born 1932 Cleveland
If Not, Not 1975-76
Canvas, 152.4 × 152.4 cm
Purchased 1976, SNGMA 1585

 If Not, Not is a seminal work, prefiguring a major shift away from 'pure' painting towards what has become known as post-modern pluralism. It is a complex painting which draws together a wealth of references and allusions. They range from T S Eliot's poem *The Wasteland* to Giorgione's *Tempest*. These sources are in themselves enigmatic and Kitaj's painting echoes them with its mysterious, dreamlike juxtaposition of distinct images. Dominating the scarred landscape, strewn with figures and fragments, is the building which is one of the keys to the painting's meaning, the gatehouse to Auschwitz. If the specific theme of the painting is the murder of the European Jews, the general theme is the malaise in modern society and the breakdown of cultural and social values. The title comes from the ancient coronation oath of the Kings of Aragon, in which the King's subjects accept the sovereign provided that he, 'observes all our liberties and laws; but, if not, not'.

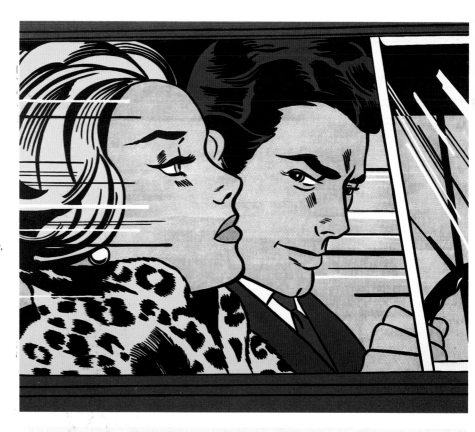

3

4

Index

Ian Hamilton Finlay (with John Andrew)
born 1925 Nassau
Et in Arcadia Ego – after Nicolas Poussin
1975
Marble, 28 × 28 × 7.5 cm
Purchased 1976, SNGMA 1583